Niki de Saint Phalle

EDITED BY SIMON GROOM

Tate Publishing

Tate Liverpool would like to thank the following
for their generous support

First published 2008 by order of the Tate Trustees by
Tate Publishing, a division of Tate Enterprises Ltd,
Millbank, London SW1P 4RG
www.tate.org.uk/publishing

on the occasion of the exhibition
Niki de Saint Phalle
at Tate Liverpool
1 February – 5 May 2008

The exhibition at Tate Liverpool is supported by
The Henry Moore Foundation and The French
Institute

British Library Cataloguing in Publication Data

A catalogue record for this book is available from
the British Library

ISBN 1-85437-7845

Distributed in the United States and Canada by
Harry N. Abrams, Inc., New York

Designed by Valle Walkley
Printed by Lecturis

Front cover: Niki de Saint Phalle, Film-Still *Daddy* 1972
Back cover: Niki de Saint Phalle, *Saint Sébastien
(Portrait of my Lover)* 1961

Foreword and Acknowledgements

It is fair to say that Niki remains something of an enigma. Despite the enormous public visibility and popular affection for her large and colourful works – one thinks of her sculptures for the Stravinsky Fountain near the Centre Pompidou in Paris, or her monumental sculpture *Protective Angel* for the main station in Zurich, or the Tarot Garden built over several acres in Garavicchio in Tuscany, or the joyful exuberance of her Nanas – her name remains, for most, unknown, in particular in the United Kingdom. Even when her name is recalled, it is more often less as an artist in her own right, than through association with the numerous collaborations she enjoyed with many of the most important, and exclusively male, artists of the era: Jean Tinguely, Robert Rauschenberg, Jasper Johns, John Cage etc. Born in France, raised in the States, and returning regularly to France where she settled to live and work, she seemed to be very much in the world, but never quite identifiable with it. Neither wholly French, nor wholly American, her name itself seems to convey something of the instability of identity her reputation suffers, as she readily assumed the nickname she had been given at school in the States, the distinctly familiar 'Niki', without ever wholly relinquishing the rather grand sounding surname she inherited from her French father. Her work, as her life, seems to be born of a tension between birthright and invention, the personal and the imaginary, the public and the private. Appearing on the chic covers of *Life* and French *Vogue*, for her beauty rather than for her fame as an artist, she appears the glamorous face of the establishment, even as her art betrayed a reality far more violent and subversive.

From the very early paintings to the very final large scale Tarot sculptures, Niki creates works of enormous power, simplicity and directness. Yet despite the fact that much of her work was informed by deeply personal issues – she first took up painting in 1953 following a nervous breakdown – there is nothing hermetic, or private about their power to communicate on a deeply human level. Much of the original impulse for many of the works remains private – although Niki did drip-feed revelations about her personal

life into the public realm, culminating in *Mon Secret* in 1993 (which may have been an attempt to provide a key to her work, as it may also have been another form of artistry) – but these revelations cannot account for the works' power or significance. Though produced by a singular vision, they possess a universality of expression. The dominant feeling is one of joy – in family, sex, colour, mundane objects, the esoteric, marriage, pregnancy, violence – in short, in life. These are all shared emotions, and provoke powerful human responses, but they ran counter to the dominant aesthetics of the art world within which she worked. The biographical nature of her work at the time of the anonymous images of Pop, or the cool, impersonal and male conceptualism of Minimalism, or the theatricality of Happenings and Performance, her interest in Tarot in the 1980s at a time of economic and political realism, and her early involvement in raising awareness of AIDS, have all conspired to make her an outsider. Above all, it is her fearlessness to translate her personal life into the shared public realm of art, with little regard for those shared public values, be they moral, religious or aesthetic – which she shares with those other outsiders of singular vision whom she most admired, Gaudí and postman Joseph Ferdinand Cheval – that makes of the real such personal, poetic and imaginary power.

Perhaps because of her outsider status, then, this is the largest exhibition of Niki de Saint Phalle's work to date in the English speaking world, and the only major presentation of her work in the UK since the touring exhibition in the McLellan Galleries, Glasgow, in 1993. The exhibition would not have been possible without the generous cooperation of key institutions who lent a substantial number of works to the exhibition. We would particularly like to express our sincere gratitude to Prof. Ulrich Krempel and Dr. Susanne Meyer-Büser, Sprengel Museum, Hanover and Gilbert Perlein and Julia Lamboley, Musée d'Art Moderne et d'Art Contemporain, Nice. We are also grateful for the loans and cooperation from the Centre Pompidou, Paris; Dr. Iris Müller-Westermann and in particular the conservators at Moderna Museet, Stockholm; and the Niki Charitable Art Foundation.

The exhibition was most generously supported by the Niki Charitable Art Foundation and we are indebted for their generosity and cooperation. Their assistance has been invaluable, and we would like to thank especially Bloum Cardenas, Marcelo Zitelli, Dave Stevenson and Jana Shenefield.

It is impossible to mount an exhibition of this kind without external funding and we would particularly like to thank the Henry Moore Foundation for their generous support and the French Institute for additional funding and promotion.

We are extremely grateful to Amy Dempsey, Barbara Rose and Sarah Wilson for contributing such valuable and insightful essays to the catalogue.

We would also like to thank Daniella Valle and Richard Walkley for their stylish design of the catalogue, and Jemima Pyne, Ian Malone, Anna Gorse and Andrew Kirk for producing the catalogue with customary skill.

We would like to express our gratitude to Simon Groom, formally Head of Exhibitions at Tate Liverpool, now Director of Modern and Contemporary Art at the Scottish National Galleries, who curated the exhibition with his usual flair and intelligence. We are also grateful to Kyla McDonald, Assistant Curator at Tate Liverpool who made a critical contribution to the selection of works and successful realisation of the exhibition and catalogue. As ever, we also thank the staff at the Gallery who have made a particular contribution to the mounting of the exhibition, in particular Wendy Lothian, Ken Simons and Barry Bentley for their meticulous care of shipping and the exhibition's installation; Jean Tormey and Maria Percival for their work on education and interpretation; and, as always, Tate conservators Sara De Bernardis, Jo Gracey and Derek Pullen.

CHRISTOPH GRUNENBERG AND ANDREA NIXON

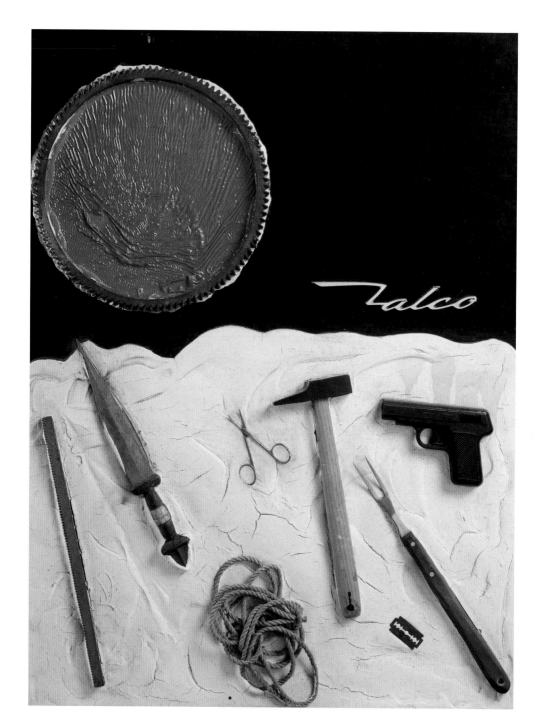

Tu es *moi*

The Sacred, the Profane and the Secret in the Work of Niki de Saint Phalle

SARAH G. WILSON

The image is perhaps our sole remaining link with the sacred: with the *horror* provoked by death and sacrifice, with the *serenity* resulting from the paƈt of identification between the sacrificed and those who sacrifice, and with the *joy of representation* indissociable from sacrifice, its only possible passage…

Julia Kristeva, *Visions Capitales*, 1998 [1]

I never shot at God… I shot at the church. I glorify the Cathedral.

Niki de Saint Phalle, 1981 [2]

[1] *Tu es moi* 1960

NIKI DE SAINT PHALLE'S work is situated in a tradition which begins with the roots of the Catholic religion in Europe and extends to our contemporaries such as Orlan. The sacred and profane dimensions of her art were born of interior conflict and the politics of her times.

At the end of her *annus mirabilis*, 1961, in which she invented her shooting paintings (*Tirs*) and cathedral pictures, and performed and shot in collaborative work internationally, she showed at the Museum of Modern Art, New York, in the highly influential 'Art of Assemblage' exhibition which opened in October (it toured to Dallas and San Francisco). *Tu es moi, paysage de la mort* entered the curator's wife Irma Seitz's personal collection – a superb compliment.[3] Niki was poised, then, at this exhilarating moment at the apex of an international avant-garde, on the cusp of neo-Dada and performance, at a moment of fête and celebration.[4]

Tu es moi (fig. 1) was made in Paris at the moment of transition from landscape assemblages to the first target portraits in the rue Alfred-Durand-Claye. A black sky with a dying red sun is poised over a white horizon, peopled not with the *personnages* of Jean Dubuffet's encrusted landscapes (which precede these formally) but with pistol, hammer, scissors, razor blade, rope, a two-pronged fork, a rod and a dagger. A crime of passion? Or the instruments of passion evoked by the echo of those black-skied crucifixion landscapes where the sun is eclipsed at the darkest moment of Christ's agony? Each object, lightly inclined to the left, invites the spectator to pick it up with the right hand and strike, or fire. *Tu es moi* – You are me: the landscape as sign of Niki's own rage? Her subsequent turns are metamorphic: the move from sun to cathedral rose to circular target-head, from folded plaster landscape to crinkly shirt are evident. *Tu es moi* anticipates *Hors d'oeuvre, (Portrait of my Lover/ Portrait of myself) (fig. 2)* the first target portrait, and the *Saint Sebastien* portraits which followed.[5]

The sun floats, disembodied, decapitated. The counterpoint to *Tu es moi*, possibly the first of the Death Landscape series, is *Collage de la mort*. A black sun is poised in a livid red sky; a doll's severed hand and a hatpin join the instruments of aggression. A stream of paint trickles like dried blood from the black sun into the landscape; it becomes the back of a looking-glass through which we cannot see, even darkly. The everydayness of the objects, already trapped, half-engulfed in a plaster burial, evokes the tradition of the *vanitas*. *Le soleil noir de la mélancolie*, the black sun of melancholy, is evoked as an act of mourning – or projection. For Niki, as for any young girl learning Gérard de Nerval's symbolist poem that introduces this black sun, an act of transference takes place: we imagine the mysterious Prince of Acquitaine in his abandoned tower, not as the poem's narrator, but as a romantic love-object.[6]

We introject, as his melancholy becomes our longing, and his loss our forward-looking yearning. *Tu et moi* – you and me – an impossible dream?

But the Death Landscapes (their titles *Paysages de la mort* coming from *Natures mortes*, still lives, 'dead natures') are highly aggressive. *Tu es moi* is also *Tuez-moi*: Kill me! Is this an imperative coming from the work itself, an exhortation to take up the pistol, the hammer, and smash the representational object to pieces? (In one of the films, Niki's repeated shots end with the crumpling of the complete armature of the *Tir* and its contents; like a dead body it slumps, bleeding, into the snow – an abject pile of mess and coloured liquids.) Alternatively, rebarbatively, is the exhortation 'Kill me!' coming from Niki herself?

In *Le Martyr nécéssaire* (*Saint Sebastien*) the dartboard replaces the head, suspended just above the empty shirt; a decapitation precedes the assault on the target-substitute. The work is an appeal to the female spectator,

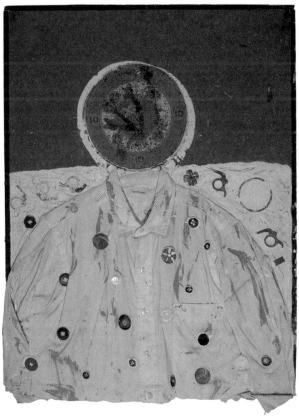

[2] *Hors-d'oeuvre or
Portrait of my lover* 1960

perverting the homoerotic, saintly subject of Renaissance art. Niki's art is an act of profanation. And what pleasure to reverse the Saint Sebastian trope, to aim one's own darts at this blank emblem of the male! The *précoce* precursor, subtitled *Saint Sebastian (Portrait of my Lover)*, with its Jackson Pollock shirt of spurts and drips, obliquely signals the impact of the great touring show, 'The New American Painting', which arrived in Paris in January 1959.[7] Pierre Restany's text, 'Tir a volonté' ('Shoot at will'), presenting Niki's work for the Galerie J in 1961, was typed over a fairground paper target spattered with holes (one recalls the ultimate Dada gesture of shooting at random into a crowd). He declared: 'There's both the cowboy and Young Werther in this pistol history... the gesture of the assassin or the cuckolded husband becomes an invitation to a voyage...'[8] For Restany this is a man-on-man shoot-out: husband versus lover. Far from empathising with Niki's desires, he does not even emphasise female agency.

The Baudelairean voyage Restany describes is into 'a world of strange marvels where blood cedes its place to the richest of colours, where explosion creates new form, where the wound is poetry...'[9] In *Shooting Picture – Galerie J* 1961, created at this very moment, rainbow stripes trickle down from the surface: a parody of the exhaustion of the existentialist gestures of an international European *informel* (one recalls the similar results of Jean Tinguely's *Painting Machines* of 1959).[10] The equivalence between shooting a victim and shooting a painting – paint as blood – evokes the whole Western tradition in which the canvas stands in for the female body: nude, love object, goddess, Venus – or alternatively the raped Europa, the raped Lucretia, the raped Sabines... Niki shoots the whole Western tradition in art. *Posséder et détruire* ('Possess and destroy'); such was the title of an exhibition summarising this tradition at the Musée du Louvre in Paris.[11] A brilliant parody, then; but is she shooting at male artists or at a body not male but female?

Tu es moi – 'You are me': the victim as perpetrator, perpetrator as victim. *Tu et moi* – 'You and me' or *Tuez-moi* – 'Kill me'? How should we respond to Nanas such as *Pink Birth (fig. 3)* where woman has moved from the rectilinear or altarpiece-shaped confines of the tableau to become all body, to acquire human, female form? *Tu es moi.* Was I this horrible, birth-giving animal splayed on its back, covered with blood, defined by reproduction, Niki asks? (*Pink Birth* was conceived and made at a time when she was recovering from a secret abortion.) The red-haired Nana's body pullulates with menageries of plastic mammals crawling towards a huge spider and an empty breast overrun with vegetation; she sports man-made machines, trains, planes – a doll hangs from her vagina. Niki's birthing mothers may be virile in the classic Freudian sense – the child as a penis substitute (Tu es moi – You are part

of me), but they are also open wounds, corpses, redundant as they crawl with new life. *Laedere* – to wound – is arguably the origin of *laid* (ugly) in French.[12] Next to this terrifying and deathly image in the Paris-Stockholm catalogue of 1980 we read in Niki's deliberately childish hand: 'Giving Birth: the virile woman. She bears the child like a male sex organ. My births turn woman into a goddess. They become at once father and mother.' Underneath a male curatorial note ripostes in print: 'To give birth standing up, in a field, like Descartes's mother! What method! Niki's virile woman leaves us dumbfounded, without an answer. Is there an answer?'[13]

Niki, of course, conceived this birth-giving Nana not standing up (to give birth to the philosopher René Descartes, the father of French rationalism) but on a flat plane, like Robert Rauschenberg's ready-made patchwork quilt *Bed* 1955, trickling with coloured paints, shown in Paris in 1959;

[3] *Pink Birth*
(Accouchement Rose) 1964

[4] Jean Dubuffet
The Tree of Fluids, 1950
Tate

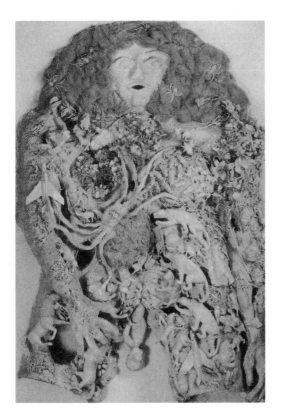

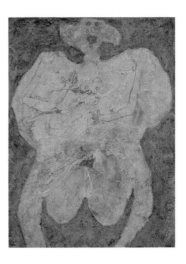

or like her fellow *Nouveau Réaliste* Yves Klein's *Anthropometries* and *Shroud anthropometries*, where positive and negative images made with 'female paintbrushes' involved real nude models, who printed their sticky bodies on canvas or loose cloth to make images then 'dematerialised' via the alchemical and sacred colours of blue and gold, and by erection of the work from the horizontal to the vertical, where they become disembodied forms, angelic flights.

Other dialogues are more disturbing, however. Niki's Nanas are direct descendants of Jean Fautrier's high-relief *Hostage* paintings, commemorating rapes and shootings, which celebrate the wound in Bataillean mode.[14] They also develop Jean Dubuffet's ugly and menacing parodies of the nude tradition such as *Olympia* and other works in his 'Corps de Dames' ('Ladies' bodies') series of 1950. (The link between Dubuffet and the writer Louis-Ferdinand Céline, who exemplifies the abject in Julia Kristeva's *Powers of Horror*, is direct).[15] Germaine Richier's larger-than-life *Hurricane Woman*, 1948–9 with its brutalised bronze surface also anticipates Niki; astonishingly, Richier polychromed her smaller sculptures before her death in 1959. This was the year of the International Exhibition of Surrealism in Paris, where the transformation of the nude into a cannibalistic feast – in the tradition of the vegetable allegories of Arcimboldo – saw Meret Oppenheim prostrated on a table and covered with fruit and food for the opening. An embodiment of Eros, and invitation to oral and sadistic aggression as woman to be devoured, she represented woman as fetish – and woman's own absorption within that fetishistic desire.[16] Surrealism was reaching a point of expiry and transformation in Niki's era, but Surrealist women of the 1950s and 1960s, from the mature sorceress Leonor Fini, to Mimi Parent or Bona, the poetess Joyce Mansour or the writers Annie Le Brun and Dominique Aury, were all subject to the spell of the Marquis de Sade and leader André Breton's muse, mistress, *femme-enfant* (child-woman) categorisations. The encounter with psychedelia in the colourful drawings and body-paintings of Myriam-Bat Josef or the Pop art of Axell in Brussels demonstrated a feminist turn: these were Niki's contemporaries.[17]

But a neo-Dada aggression liberated Niki's art from Surrealist affinities. *Tu es moi*, You are me, Niki declares – just as Gustave Flaubert identified with his most famous, sexually profligate creation, Emma Bovary, *Madame Bovary c'est moi*. On the one hand, says Niki, addressing male artists, you create beautiful – or horrible – nudes because you are afraid of woman and her power, including her power of procreation. The idealised 'beautiful' image terrifies in its perfection, its unattainability; the apotropaic dimension of the nude is at stake here. The 'dirty' nude of a Dubuffet corresponds to the infantile wish to destroy, to defile, to scratch, to score, to cut up the body, the 'bad breast':

see his *Piece of Butchery* or *Tree of Fluids (fig. 4)* (both 'Ladies' bodies' series), where the image liquefies, spreading dangerously to the four corners of the canvas, threatening to engulf its creator in pre-natal memories.

Contemporary French culture exalted the glamourpuss, from Roger Vadim's creation of Brigitte Bardot as the ultimate, God-created woman in his film *Et Dieu... créa la femme* 1956, to Martial Raysse's *Nouveau-Réaliste* bathing belles. Compared with Niki's slim and fashionable body, whether beauty plate for *Vogue* or queen bee at the *Nouveau Réalistes* private views, the Nanas are the monstrous, ugly, misshapen 'other self', sticky with the 'viscous' feminine, abhorred by the existentialist philosopher Jean-Paul Sartre and even his feminist partner, Simone de Beauvoir, author of *The Second Sex*.[18] Is the Nana the 'bad mother', a fearful effigy for Niki herself, who left her own two children and her husband to work with Jean Tinguely? Does Niki shoot the effigy of the mother she once was, all 'earth mothers', or the 'bad mother' she fears?[19] Her problematic 'destructions of the mother' precede by a decade Louise Bourgeois's *Destruction of the Father* installation of 1974.[20]

But Niki also expressed a political anger. The impact of the Nana's ugliness inverts and vilifies not only the cult of female beauty and fertility but the trope of sacred and virginal motherhood, the Madonna so central to the Western artistic tradition (explored later in the 1970s by Marina Warner and Julia Kristeva).[21] The title of her 1962 OAS altarpiece contains another pun: *Oeuvre d'art sacré* (sacred work of art) or *Organisation Armée Secrète* (the secret right-wing nationalist army). The altarpiece, gilded with an ecclesiastical pomp, is an act of sacrilege with its saintly effigies, its guns and its massacred innocents. Neither the French Church nor the Vatican denounced the Algerian slaughter; missionaries accompanied France's 'civilising mission' in Africa from the start, while the concept of colonised territories as 'greater France' entailed lucrative rewards. The altarpieces evoke the Church itself as an ultimate patriarchal institution, one whose power over the most sacred rites of passage – baptism, marriage, death – evoked moral principles constantly abused. Niki's Nana altarpiece, *Autel des femmes* 1964, with its bride, flying Nana stuffed with skulls and 100 franc notes, flying military jets and capitalist skyscrapers denounces the real and symbolic prostitution inherent in the system.

The models on the covers of *Vogue* or *Paris-Match* were now juxta-posed with headlines about systematic rape and torture by French soldiers in Algeria.[22] Here, Niki's art becomes a voice of protest. She transforms the female body, which – as in medieval love poetry – represents the body of France into a militarised landscape, whether 'occupied' by American troops or shot and blown up, mimicking bomb attacks and police brutality in Paris. The almost sexual ecstasy that she describes while shooting, the 'sublime' moment followed by fatigue,

disappointment, exhaustion has arguably a counterpoint in the excitement, horror and disbelief of the militarised teenage conscripts, her counterparts in a 'France torn apart' by this unnamed war. (*La France déchirée* was indeed the title of a torn-poster show of 1961 by her *Nouveau Réaliste* contemporaries.)[23] The shooting-painting *Tirs* can become 'tears' of shame, pain, desecration, mourning or relief. The year the *OAS* altarpiece was exhibited, 1962, Pierre Guyotat was expelled from the army for moral turpitude following two years in Algeria; his novel *Tombeau pour cinq cent mille soldats* (*Tomb for 500,000 Soldiers*) with its intense sexual scenes between combatants was banned from military barracks.[24]

What happens when the Nana becomes a man? Or to reverse the proposal: what is implied when the monstrous Siamese twin Nana, *Kennedy-Khrushchev*, becomes a woman? Created in 1962 in the Impasse Ronsin in Paris – where Brancusi once sculpted his smooth and beautiful birds – this most

[5] *Nana Maison I* 1966–67
PHOTO: Ad Petersen

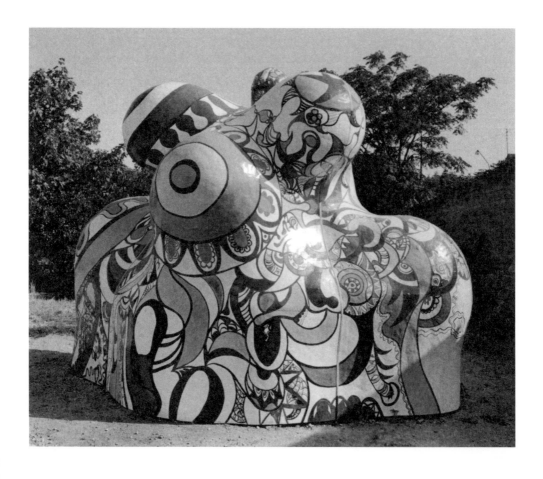

angry of Niki's shooting pieces asks the most disturbing questions. Completed with a shoot-out, it anticipates the tense moment of the opening of the New York–Moscow telephone hotline in June 1963 and Kennedy's November assassination. Just as the Nana's body could become the equivalent of a country to explore, here again is the metaphor of the body politic, now signifying Cold War apocalypse. However, the two world leaders are humiliated not only via their stripping, but through their castration, through their feminisation. The blackened pubis becomes a place of shame and ashes. *Tu es moi*: you have become me. The sexual humiliation of political victims, taking place at that very moment in the French-Algerian conflict, is acted out here as revenge. While a sister piece, *Red Witch* 1963, may take upon itself all the fairytale empowerment of the monstrous feminine, of the vampire killer, with *Kennedy-Khrushchev* the sexual politics at stake of feminising the enemy – a practice re-enacted today between victors and victims – is ambivalent in the extreme: women's anger expressed through self-reflexive humiliation?

Niki's *Crucifixion* c. 1965, made in the Chelsea Hotel in New York, is a suspended Nana – clothed, not naked, with its huge square body, tiny head in curlers, and residual arms. An *arcimboldesque* jungle top of vegetation, soldiers, dolls and animals, like a flowery blouse, is tucked into a huge pink spotted suspender belt; thick thighs turned outwards taper into black lace stockings and tiny stilettos. A female Christ: profanation, blasphemy, or a resurrected reversion to the goddess-mother? *Crucifixion* anticipates by a year Niki's *Hon (She)* the massive, collaborative, splendid woman-cathedral created inside Stockholm's Moderna Museet in 1966. The associations of fertility shrines, ancient priestesses and the origins of the cathedral arch and brothel in the Latin word *fornix*, the sacred labyrinths traced on the floors of ancient churches, come together here – but so does the etymological link between women and evil, flaunted at the entrance to this fun-palace. On the garter of the *Hon*, by the vaginal entrance, Niki inscribed the motto 'Honi soit qui mal y pense': Evil to him who evil thinks.[25] Celebratory, democratic – a group 'rebirthing' experience – the *Hon* was a worldwide press sensation, foreshadowing the spirit of the 1967 Summer of Love.[26] It anticipated a climate in Scandinavia in which over 250,000 people went to see the First and Second International Exhibitions of Erotic Art in Sweden and Denmark in 1968 and 1969, in public museums.[27] Its success led to Niki's commission with Jean Tinguely for the Paradise Garden on the roof of the Barbican-like French Pavilion at the Montreal 'Expo 67', where 'Nana-kebabs' (*Nanas-en-brochette*) spun around joyously in the air. A tour followed: a treat for the Albright-Knox Gallery in Buffalo and then for lovers and Harlem kids in Central Park, New York. Together with the 'marvellously tattooed' *Nana-Maison (fig. 5)*

shown in the Musée Galliera, Paris, these became Niki's contribution to May '68.[28] The *Nana-Maison* anticipated the sets for her play *ICH (all about me)* performed at the Kassel Documenta of 1968 in June. By November, with her show of an eighteen-part wall relief, *Last night I had a dream*, at the Galerie Alexandre Iolas, Paris, she was recognised as 'the most important female artist of the era'.[29]

Though Niki's focus was now on large-scale sculptural projects, she participated in the tenth birthday celebrations of the *Nouveaux Réalistes* in 1970; Jean Tinguely's giant golden phallus exploded in front of a crowd of thousands. The sacred dimension was essential: the ghostly and magnificent night-time façade of Milan cathedral was the immemorial backdrop; the phallus ejaculated in sound, smoke and fury, then imploded; the cathedral remained.[30] Niki's commemorative altarpiece shoot-out held in the long promenade of the Galleria Vittorio Emmanuele – a particularly bloody event performed in front of horrified believers and the Milan police – magnified her first posed sessions in her white shooting outfit on the parvis of Notre-Dame in Paris, taking the place of the *jongleurs* of old; shooting the church, glorifying, identifying with the transcendent cathedral; never shooting at God.

Who was God? A white death mask, the decapitated *Gilles de Rais (fig. 6)* of 1964, commemorates this associate of Joan of Arc, satanist and child abuser, tried by ecclesiastical court in 1440.[31] He seems to subsume in himself the heads of Kennedy Khrushchev, Castro, Abraham Lincoln and Father Christmas, masks stuck to the 1963 study for the premonitory *King Kong* shoot-out (where the jets hit the skyscrapers). *King Kong*, we remember, is a love story. While Niki's own childhood traumas of the 'summer of serpents' was notionally repressed at this time, Gilles de Rais has a serpent on his brow; Georges Bataille's republication of the trial with the controversial editor Jean-Jacques Pauvert re-focused attention on the medieval atrocities in 1965.[32] In 1972 Niki started shooting the film *Daddy (fig. 7)* with English film-maker Peter Whitehead: her family chateau setting situates the film directly in the pornographic lineage of the Marquis de Sade, Dominique Aury's *Histoire d'O*, 1954, and Bernard Noël's *Le Château de Cène*, 1969, but it is closer to a rampaging Ken Russell film fantasy. 'Agnes' (Niki) is played by Niki herself and actresses representing her at five, but also a provocative fifteen; mother Clarisse ('the one who did screw') was also a character. Whitehead – keen on the Electra complex – turned from documentary to psychoanalysis when shooting what he defined as a woman's means of revenging herself on her father's omnipotence ('Young Niki' replays 'blindfolding Daddy' before he is sexually humiliated and shot – with the *Death of the Patriarch* shoot-out painting as supplement); 'we went back to the point when daddy did or did not rape her... perhaps she had tried

to seduce him' said Whitehead. Niki concluded 'I feel now that I am both man and woman'.[33] Gestures towards contemporary anti-psychiatry which reflect the pansexuality of the times are more present in the film's carnival excesses than any psycho-analytic conclusion; but shown in London's Hammer Cinema with a revised world première at the Lincoln Center, New York, in 1973, this was yet another violent self-experiment which repeated – as did the *Tirs* – a self-catharsis.

Daddy, like God, never stopped haunting Niki:

Daddy was a church goer, said God could not be dead,
but his taste was not so Catholic with the girls he took to bed,
especially to virgins he played the host

[7] Film-Still *Daddy* 1972

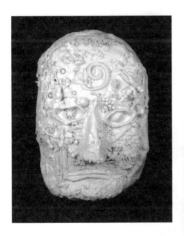

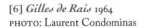

[6] *Gilles de Rais* 1964
PHOTO: Laurent Condominas

whom he deflowered with the holy ghost
and for their first communion took their bodies and their blood

… Are you having a good time Daddy?[34]

The patriarchal assumptions against which Niki de Saint Phalle fought all her life were never more evident than in Paris in 1972, when she figured as one of only two women in the great retrospective held in Paris's Grand Palais, *Douze ans d'art contemporain*, popularly known as the 'Expo Pompidou' or '72 for 72', starring seventy men – a proportional representation that seemed entirely appropriate to the young exhibition organisers who still rule France's art establishment today. Left-wing feeling ran so high that many refused to participate in a 'State' exhibition (notorious for the violent confrontation between police

[8] *Black Venus* 1966–67
PHOTO: Galerie Alexandre Iolas,
Paris

and artists at the opening). Niki's commemorative Milan altarpiece was on show here, together with an upside-down Nana and the gothic, Miss Haversham-like *Bride*, which almost immediately entered the national collections. Sheila Hicks's large textile environments, displayed prominently and near the entrance, were also feminist statements, in their materials, their technique and titles.[35] But while Hicks chose anthropologist Claude Lévi-Strauss's text about her work, Niki added her own voice to appreciations by leading critics such as Pierre Restany: 'Me? A savage? She has finally found an answer, that a woman in a man's civilisation is like a black in a white civilisation. She has the right of refusal, the right to revolt. The bloody battle-flag has been raised.'[36]

Niki's sense of injustice rings with the contemporary resonance of the Black Rights movement in America: her great *Black Venus (fig. 8)* 1967, would enter the Whitney Museum collection in New York: a celebratory, contemporary response to a theme with a long and vexed history.[37] (*The Mouvement de la Libération des Femmes* – the French Women's Lib movement – which demonstrated outside '72 for 72' was in its infancy). The proportional representation – two women, seventy men – corresponds almost exactly with the statistics Linda Nochlin gives, covering the context of publication of her pioneering article of 1971, 'Why Have There Been No Great Women Artists?'[38] But by now the American feminist context was exploding with the 1972 'Festival of Women in the Arts' at Cornell, the NOW conference on female sexuality, the Erotic Art Gallery. The discussion around overtly 'feminist' creations, the sexualised flowers of Georgia O'Keeffe, or Judy Chicago's classic *Dinner Party* 1973–9, became displaced by works that were more violent and more gender-sophisticated.[39] Bourgeois's *Cumulus* no. 1, with its white marble phalli in the Tate Modern retrospective, must be reimagined in its 1973 New York context of 'Metaphorical Cunts and Measured Cocks'.[40]

By the later 1970s, when Niki (like Jean Dubuffet) was involved with major monumental projects, feminism was finally making short-lived inroads into French art and society.[41] In 1979 the Galerie Yvon Lambert staged 'Artemisia', a homage to Artemisia Gentilleschi, Niki's great precursor – a female artist raped. Artemisia's *Judith and Holofernes* 1567, seemed to the eyes of the late 1970s, to transcend its Biblical subject matter with a personal energy of revenge. The show brought together conceptualism (Daniel Buren, Jospeh Kosuth), Arte Povera (Jannis Kounellis), sensual painting (Cy Twombly) and staged photography (Duane Michels). In the catalogue to the exhibition, the philosopher Roland Barthes contrasted the structural simplicity of the core narrative with the variations through history of the apocryphal story of decapitation. It was artist Lea Lublin, however, who brought us back to Niki's similar beheadings, her open wounds, her birth in death and death in birth:

her *Tuez-moi – Tu es moi*. In Artemisia's beheading of her assailant, Lublin sees rape as a ghastly birth, the birth of the father:

> Death scene, the staging of the body by the reversal of these fragments, also shows up the scene of defilement, the rape scene, the castration scene, the birth scene, the birth… In Artemisia Gentilleschi's picture, if the reversal of the centre of the painting moves and changes the image, due to the course it takes from the murder to the birth, it is because the two women in the picture, Artemisia and her double, hide a third who appears as the beheaded, bearded man. Within the limits of the picture's subject, is the butchered, bearded man, the assailant of the biblical tale, the invader, the seduced and beheaded occupier, the father or professor of perspective, the disciple of the father-painter, the master of the laws of perspective, the rapist, the robber? Within the limits of the picture's subject, is it the painter-woman who shows herself defiled, raped, sexed, bloody? Or her Other and her drives full of weighty prohibitions, of repressions, religious, symbolic, sexual? The desires and the ensuing unconscious processes unleashed – punishment, castration complex, guilt, putting to death – transgress the space of prohibitions, by denuding a body in order to show the course of desire and the limits of a symbolic space which cover it, which violate it, which erase it. Desires and prohibitions, prohibitions of incest, murder, guilt, throw us into the species' phylogenetic memory, its law, its taboos, and its traces which persist or which reappear there where they warn us of the appearance of their symptom.[42]

It was two whole years later, 1982, and an entire decade after Saint-Phalle's *Daddy*, that Louise Bourgeois – the first female artist to have a retrospective at the Museum of Modern Art, New York – launched her late career and the big bang of contemporary scholarship with her *Artforum* article 'Child Abuse'.[43] That moment might now appear reframed – or at least interestingly enriched – by looking at artists and criticism from Europe.

Niki's book *AIDS: You Can't Catch It Holding Hands*, published in 1986 while she was working on her Tarot Garden in Garavicchio, was subsequently translated into five languages. The desire to 'come out' on behalf of young victims of abuse was at the heart of *Mon Secret* 1994 *(fig. 9)*. Yet this confessional book, framed as a letter to her daughter Laura, in Niki's loopy, childish hand-writing, remains an untranslated secret. Two decades after *Daddy*,

she tells the story of the 'summer of serpents', her violation at the age of eleven in 1942 (Tu es moi – Tu es à moi: You are part of me – you are mine: the very core of incest taboo). It is the passionate denunciation of rape: the massacre of an innocent.[44]

The discretion of this 'secret' and the lack of critical literature on Niki until recently, contrasts with the public visibility of her later works, and the 'Niki' style associated with the products generated to finance the Tarot Garden, her ultimate monument to Gaudi and the Facteur Cheval – and herself. A visibility ratifying invisibility: never more so than when, in 1992, Pontus Hulten's retrospective *Territorium Artis*, inaugurating Bonn's major new art museum, looked back at the 'art of our century': ninety-six men, with Niki shown comprehensively on the roof of the building – the bride floating above the bachelors as in Montreal, 1967.[45] In his introduction for her Paris

[9] Cover of *Mon Secret* 1994

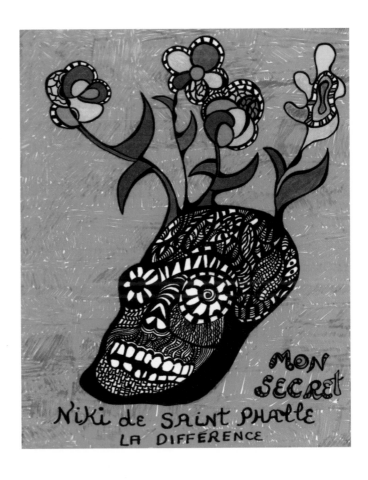

retrospective in 1993, Hulten declared: 'She looks at what the great artists of modern art preceding her have produced. With innocence, like a blithe spirit, she borrows from them, as if she were picking flowers in a beautiful garden…'[46] The magnificent Stravinsky fountain, outside the Pompidou Centre, a Niki and Jean Tinguely collaboration, belies the uneasy consensus within. Why does Niki still need rediscovery in and beyond France?

'I always find it strange that though my personality, my accent, my attitudes are so American and I was raised in New York, no one thinks of me as an American artist which is what I really am.'[47] Is Niki far too French for a third generation of feminist art historians in 2008? (There is not a trace of Niki in the influential publication *Women Artists at the Millennium*, 2006). Are her love stories, her hate stories, and in particular her loving and working partnership with Jean Tinguely, too strong to rate in its often too separatist stakes?[48] Marcel Duchamp, Niki de Saint Phalle, Louise Bourgeois: all work with their twinned French and American identities, the clash of cultures and languages. As with Bourgeois, Niki's vivid personal memoirs add a supplement to the psychoanalytic interpretations we can bring to her works.

With *Traces, An Autobiography. Remembering 1930–1949* (1999) and with *Harry and Me, The Family Years, 1950–1960*, published posthumously in 2006, Niki was able to create her own family monuments. The Bad Mother is redeemed (Harry Mathews pays compliments to Niki's selflessness), her own strict mother is saluted, the wife, the good lover, the imaginative, violent child, the artist are celebrated, as is the determination to make paintings, assemblages, sculptures, grottos, gardens, homes, and, with the *Hon*, to make a cathedral out of herself.[49] The sacred and the profane, the masculine and the feminine, love and hatred, *Tu es moi, Tu et moi, Tuez-moi* – and the joy of representation (our sole remaining link with the sacred, as Kristeva says) all are here. In speaking, too, of '*serenity* resulting from the pact of identification between the sacrificed and those who sacrifice', Kristeva allows a conceptual space, the space of this pact, for the the innocent, the celebratory and festive dimensions of Niki's immense later *oeuvre*, produced with the convictions of an epoch whose mantras of love, peace, liberation, colour are apparently so far from our own. Our preoccupations are darker, more cynical; we exist in the shadow of the black sun.

Bad enough, brave enough, good enough: Niki de Saint Phalle takes her place with the GWAs (Great Women Artists) of the twentieth century.

Thanks, as ever, to my students and to the staff of the Bibliothèque Kandinsky, Musée National d'Art Moderne, Centre Georges Pompidou.

Family Portrait
1954–55

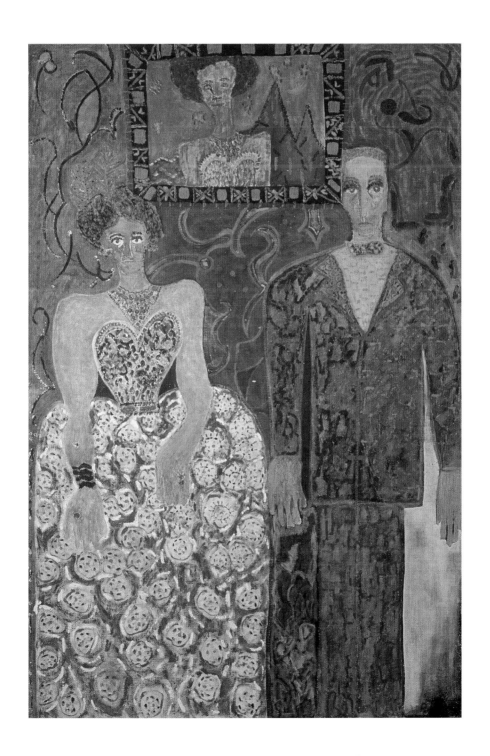

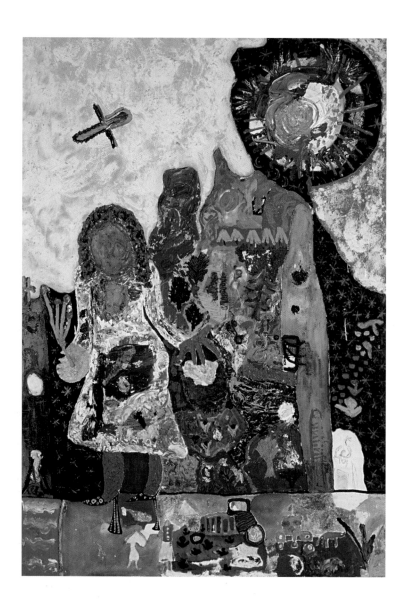

Entre la ville et la fleur
(Femme entre la ville et la fleur)
c. 1956–58

Pink Nude with Dragon
c. 1956–58

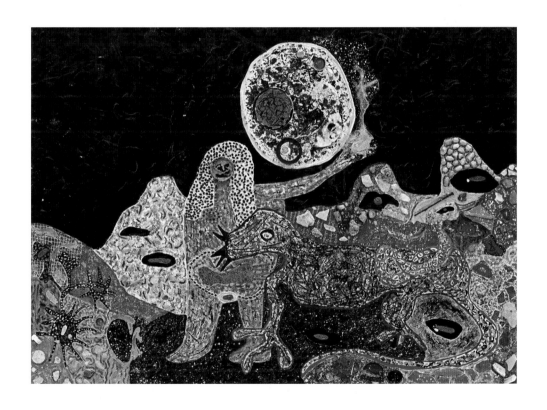

Night Experiment
c. 1959

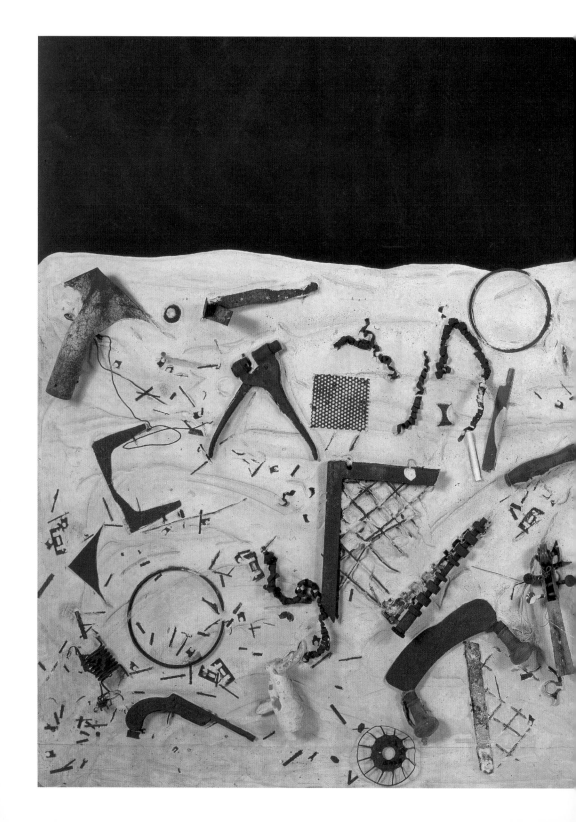

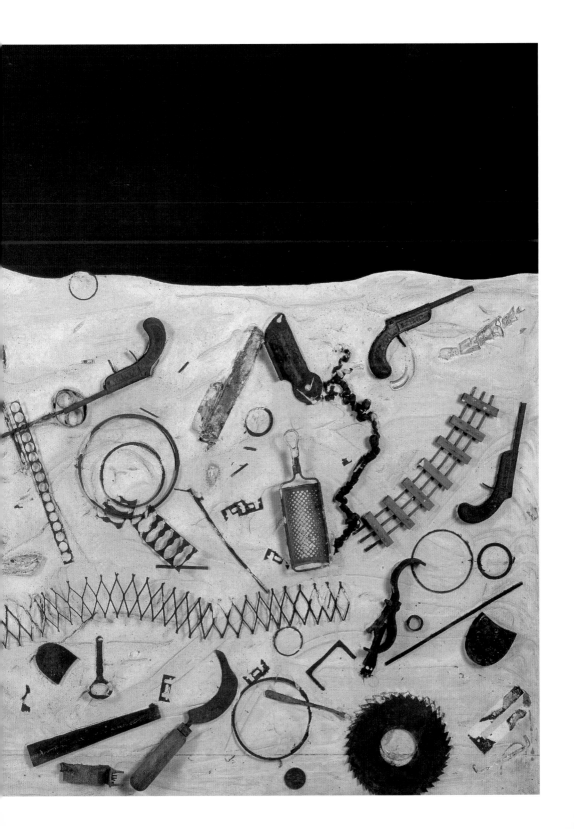

Auto-portrait
c. 1958–59

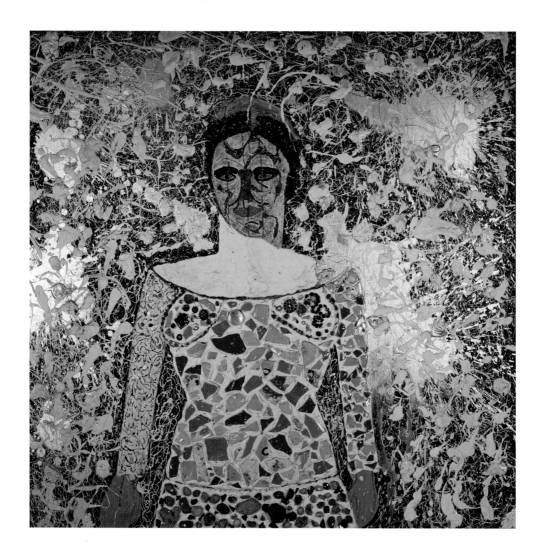

32, 33

Paysage de la mort
(Collage de la mort)
1960

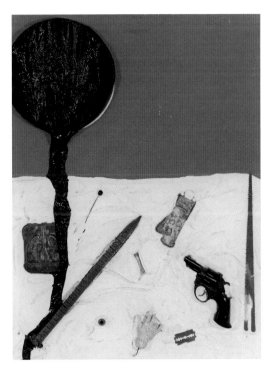

Le Hachoir
1960

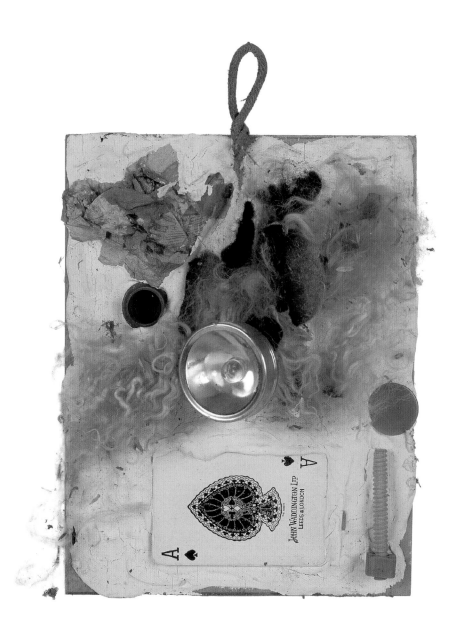

Ace of Spades
c. 1960–61

Rubber Glove and
Three of Spades
c. 1960–61

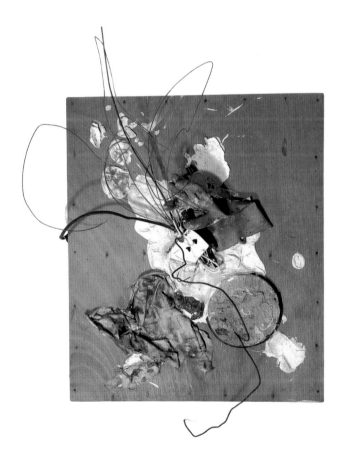

Two Cowboys
c. 1960–61

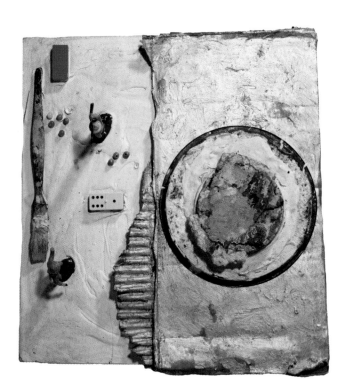

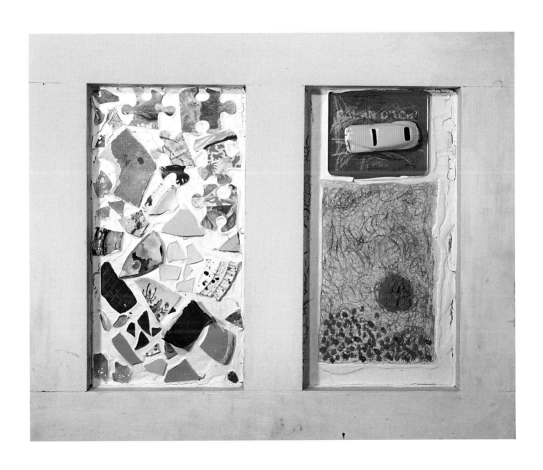

Toy Yellow Car
c. 1960–61

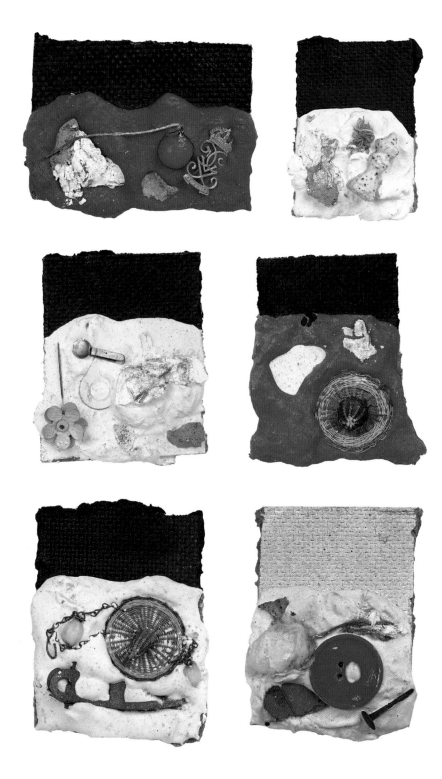

Brooch
Chess Pawn
Fleur
Petit chapeau
Petit Sombrero
Red I
Red Ribbon
Rusty Nail I
Screw Hook
Wood Ball
1961

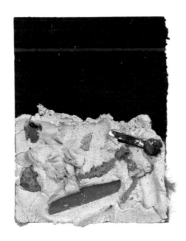

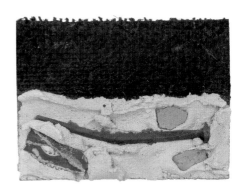

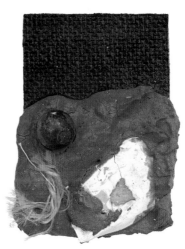

String I, 4, 5, 6
1961

40, 41

Fusée et Gant de Caoutchouc
c. 1960–61

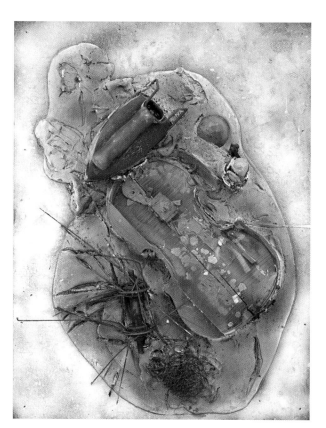

Violon
c. 1960–61

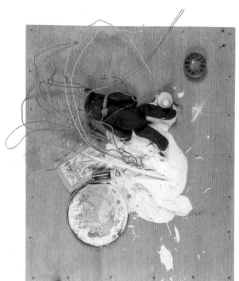

*Van Harte Betterschap
(Valentine)*
c. 1960–61

42, 43

Face/Self Portrait
1963–64

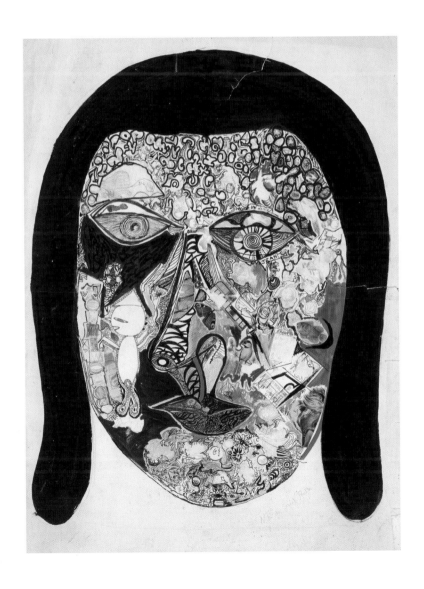

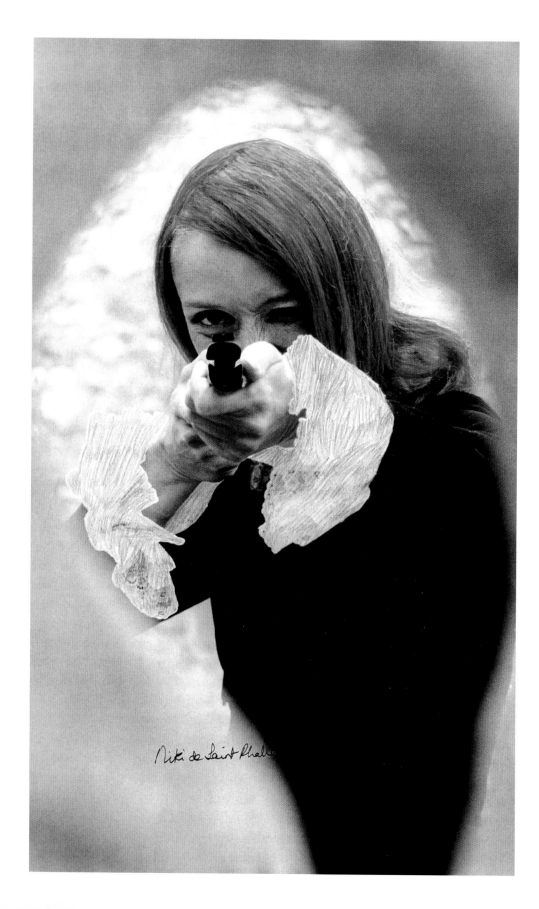

Niki de Saint Phalle enters the art scene with a *bang*

AMY J. DEMPSEY

Men say she has a magic pistol
Which can turn plain glass to crystal
And can change an apple cart
To a splintery work of art!

Kenneth Koch, *The Construction of Boston*, 1962

Film-Still *Daddy*
1972

SAINT PHALLE'S FIRST 'SHOOTING' took place behind her studio at 11 Impasse Ronsin on 12 February 1961 *(fig. 1)*. Among those in attendance were Pierre Restany and his future wife, Jeanine de Goldschmidt, who would open Galerie J later that year. On the strength of the four paintings created, Restany invited Saint Phalle to become a *Nouveau Réaliste* (New Realist). On 26 October 1960 at the home of Yves Klein, Restany had officially founded the *Nouveau Réaliste* group. Together with eight artists – Frenchmen Klein, Raymond Hains, Arman, François Dufrêne, Martial Raysse and Jacques de la Villeglé, and the Swiss artists Daniel Spoerri and Tinguely – he signed a declaration on 27 October stating, 'this is *nouveau réalisme*: new perceptive approaches to the real' *(fig. 2)*. This basic platform provided an identity for collective activity and encompassed the very different work of these artists, and of others who joined later, including Saint Phalle, France's César and Gérard Deschamps, Italy's Mimmo Rotella, and Bulgarian-born Christo.

Work by the European *Nouveaux Réalistes* is notably diverse and covers such widely different art as the torn posters of Hains, the assemblages of Spoerri, the wrapped packages of Christo, the 'accumulations' of Arman and the shooting paintings of Saint Phalle. What they have in common, however, is the sharp and deliberate contrast they make with the mainstream modernism of the time. By the late 1950s, with the proliferation of second- and third-generation practitioners, Abstract Expressionism and Informel Art seemed to many to be in danger of becoming an academy, conservative and out of touch with social realities. The conditions of deprivation and angst in which the first generation of post-war artists had worked had been replaced by a new society of increasing affluence, technological advance and rapid political change. It was this world that the *Nouveaux Réalistes* explored.

Nouveau Réalisme is generally presented as the French counterpart to American Pop, but the artists relate more closely, in fact, to the American Neo-Dadaists, such as Robert Rauschenberg, Jasper Johns and Larry Rivers, with whom they formed strong ties of friendship. Like them, the *Nouveaux Réalistes* drew inspiration from Dada, Marcel Duchamp's readymades, the Surrealists' appreciation of the 'marvellous' in the ordinary, and the Cubist machine aesthetics of Fernand Léger's 'new realism'. They were also united in their rejection of the cult of the artist that was associated with the abstract painters, and in their encouragement of audience participation in their work. The artworks by Saint Phalle and the other *Nouveaux Réalistes* and Neo-Dadaists provide a rich array of associations and possible meanings that are indicative of the times, which were tense, joyful and constantly changing. They encourage multiple readings, the free play of the intellect and refuse to provide a single, special, worthy 'meaning'. They proclaim the desire to be in

and of this world, not outside or above it. They are fusions of the mental and the physical, personal and universal, private and public, past and present.

Saint Phalle's second 'shooting' was held on 26 February 1961 in the Impasse Ronsin with a number of her fellow *Nouveaux Réalistes* present. Her work was then included in the international 'Movement in Art' exhibition at the Stedelijk Museum in Amsterdam, Netherlands (10 March–17 April), which included an outdoor shooting of paintings hanging in a tree. The exhibition, organised by Willem Sandberg and Pontus Hulten, was enormously popular, breaking all attendance records, before travelling to the Moderna Museet in Stockholm, Sweden, and the Louisiana Museum of Modern Art in Humlebaek, Denmark.[1]

Meanwhile, back in Paris, exposure was accelerating. *Nouveau Réalisme* was brought to the attention of the wider public on the Louis Pauwel

[1] Saint Phalle's first 'shooting' at her studio at 11 Impasse Ronsin on 12 February 1961.

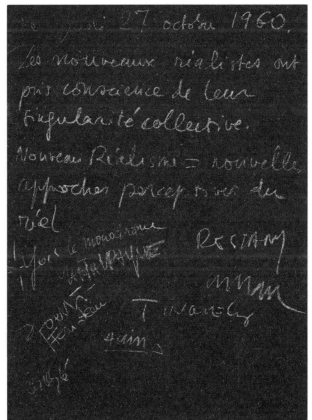

[2] *Declaration of Nouveau Réalisme* 1960, chalk on paper painted blue, 100 x 66 cm.

television programme, *En français dans le texte*, broadcast on 25 April 1961. On the programme, Restany presented the work of Arman, Dufrêne, Hains, Klein, Saint Phalle and Tinguely. The programme was announced by a two-page spread in the television guide, *Télé 7 jours*, inviting the public to enter the 'strange world' of the avant-garde.[2] The spread featured large pictures of Dufrêne, Tinguely and Saint Phalle, whose work could be seen in a number of exhibitions in the spring and summer. The comedian Danny Kaye is mentioned as a long-time admirer of Tinguely's work and Saint Phalle is shown attaching eggs to a painting to be shot at with a revolver. The promotional article and the television programme itself are examples of the mass media embracing and supporting avant-garde art at an early stage and bringing it to an audience beyond gallery- and museum-goers and art journal readers. This demonstrates the way in which the art world would expand in the 1960s to include new

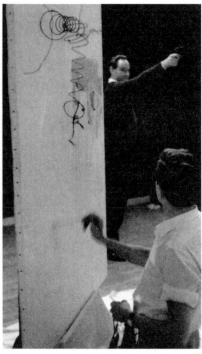

[4] Performance of *Variations II*, US Embassy, Paris, 20 June 1961, marksman shooting at Saint Phalle's assemblage, Robert Rauschenberg painting.

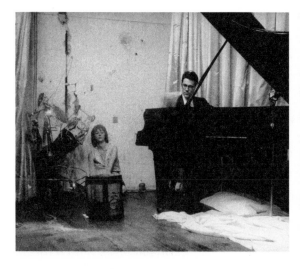

[3] David Tudor during the performance of *Variations II*, US Embassy, Paris, 20 June 1961.

consumers and collectors from outside the educated elite – the middle classes, Hollywood celebrities, the popular media, and so on. Both the art and the artists were brought into people's homes and made available for identification and discussion, fostering a change during the 1960s in the archetypal role of the artist from being 'solitary and misunderstood' to being in the public eye. Restany recalls that the programme was greeted with laughter from the media and derision from the art critics, but that it left a lasting impression on the viewer beyond that of mere scandal, and that it certainly attracted a wider audience to the upcoming exhibitions.[3]

The activities continued throughout the spring and summer, with both Robert Rauschenberg and Jasper Johns in Paris for solo exhibitions. David Tudor, the celebrated pianist who often collaborated with composer John Cage, was also in town as part of a European concert tour. Rauschenberg, with the help of Darthea Speyer, cultural attaché to the American Embassy in Paris, arranged to present a performance of Cage's *Variations II* (1961) at the Embassy in Tudor's honour on 20 June. He invited Jean Tinguely and Niki de Saint Phalle to participate.[4]

While Tudor played the piano on one side of the stage, Rauschenberg worked on a 'combine' painting on the other side, with his back to the audience so that they could not see what he was doing *(figs. 3, 4)*. Microphones were attached to the easel which amplified the sounds of brushstrokes, hammer blows and other onstage activities. These included a 'striptease' machine by Tinguely that wandered around the stage shedding metal parts, and a shooting painting prepared by Saint Phalle that was shot by a professional marksman hired by the Embassy.[5] Johns contributed a flower target which was placed on stage and a painting, *Entr'Acte*, which was carried across to announce an intermission that never took place. Ten minutes before the end of the performance, an alarm clock installed in Rauschenberg's painting went off and a porter from the Hôtel du Pont Royale, where Rauschenberg was staying, arrived to help him wrap and carry off the work through the audience without letting them see the final result. Tudor spent most of the time beneath the piano.

The experience for the audience would have been both aurally and visually distressing as well as stimulating, with the strains of the piano overlaid with the sounds of gunshots, hammer blows and scraping metal. A gunman entered and fired, not with precision at the target but repeatedly and apparently randomly, at a work that spurted and bled as it was shot; this work was located between two human beings, one hiding behind a canvas and the other under a piano; and the gunman was someone trained to kill, not an artist. The battle between culture and war, creation and destruction was played out

in an assault on the senses that included the smells of gunpowder and paint. The audience's discomfort is easy to imagine.[6]

These themes of self-destruction, creation out of destruction, war and peace, violence and friendship, optimism and despair, are inherent in the individual artworks and the event as a whole. The 'cultural occupation' of the US Embassy for the event was another important factor – an artistic 'sit-in' by European and American artists in the space of the very organisation that was supplying the FBI with information on the activities of 'communist' artists, as well as an institution whose duty was to protect American interests and to represent the United States as an ally of France.[7] Whatever the cultural and political reasons for authorising the performance, Darthea Speyer was 'highly criticized for it by US Information Service officials and ... forbidden to organize anything similar again under any circumstances'.[8]

The political events of early 1961 were also a combination of hope and anxiety – the nuclear build-up, the Bay of Pigs fiasco, the unresolved Algerian crisis, the first man in space and the recent election of President Kennedy and the hope that it inspired. While not intentionally a direct interpretation of international events, the performance certainly resounded with the spirit of the times: Tinguely's machine, self-destructing as it 'danced' across the stage, the act of ritual aggression necessary to complete Saint Phalle's work, and the secrecy of Rauschenberg's production, going on – like politics – 'behind closed doors'. These works acknowledge the provisional status of art, life and meaning. The *Variations II* performance provided a powerful expression of an anxious time by a group of international friends, seemingly an act of mutual recognition of difference and identification – yes, we are European and American, but we are also young, liberal and exploring ways to express ourselves in an uncertain time created by our antagonistic elders.

Saint Phalle's first solo exhibition at Galerie J, *Feu à volonté* ('Fire at will', 30 June–12 July) followed shortly afterwards. Johns and Rauschenberg helped to install the exhibition, which turned the gallery into a shooting range. At the opening on 28 June, visitors were invited to shoot at the reliefs to complete the works *(fig. 5)*.[9] *Tir de Robert Rauschenberg* and *Tir de Jasper Johns* were among the works exhibited after being shot by each artist *(fig. 6)*. Each assemblage effects an homage to the artist, and the works were not completed until shot by Rauschenberg and Johns. The result is both an impressive parody of Abstract Expressionism and of the high seriousness it entailed, and of the 'preciousness' of artistic creation. Having Rauschenberg and Johns, both willing participants, shoot at works that were made (by Saint Phalle) to look like their own, is to have them destroy their own work in order to create a new one. They have been afforded the honour of taking part in

their friend's work and of being the subject of a tribute, but are required to 'shoot themselves' in the process, effectively fusing the two personalities in a relationship in which Saint Phalle's is the dominant one.

Restany was one of the first to notice the growing friendships between many of the American and European artists. In 1961 he organised the first emblematic exhibition of their work at the Galerie Rive Droite in Paris, entitled *Le Nouveau Réalisme à Paris et à New York* (18 July–10 October). This included work by the *Nouveaux Réalistes* and the Americans Rauschenberg, Johns, John Chamberlain, Chryssa, Lee Bontecou and Richard Stankiewicz. The presentation of European and American artists working in a sympathetic vein was continued and expanded in a major exhibition at the Museum of Modern Art in New York in the autumn of the same year (4 October– 12 November). Called 'the great New York event of 1961',[10] 'The Art of

[6] *Tir de Jasper Johns* 1961, mixed media, 117 x 59 x 26 cm.

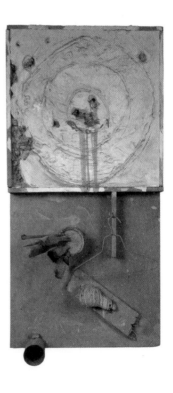

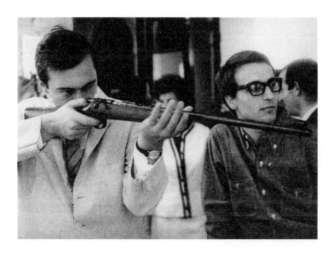

[5] Niki de Saint Phalle's 'Feu à volonté', Galerie J, Paris, 1961. Jasper Johns shooting, Frank Stella watching.

Assemblage', curated by William C. Seitz, included work by the *Nouveaux Réalistes* and the new American artists such as Johns, Rauschenberg, Marisol, Bontecou, Chamberlain and Ed Kienholz, as well as their Cubist, Dada and Surrealist precursors.[11]

The following year was to be equally sensational for Saint Phalle. On Sunday 4 March 1962 at 4.30 p.m. her first 'shooting' in the United States took place in the car park of the Renaissance Club on Sunset Boulevard in Los Angeles, California *(figs. 7, 8)*. She was assisted in the creation of the shooting assemblage by Tinguely, Kienholz and Rauschenberg, and the event was sponsored by the Everett Ellin Gallery. Her technical assistant was Kienholz, 'who loaded cartridge after cartridge into his "little .22" and handed it up to her on the ladder'.[12] Saint Phalle was by this time wearing a special outfit for her shootings, a white bodysuit and shiny black boots. Those in attendance,

[7,8] Niki de Saint Phalle during her first shooting action in the United States, sponsored by the Everett Ellin Gallery, Los Angeles, 4 March 1962.

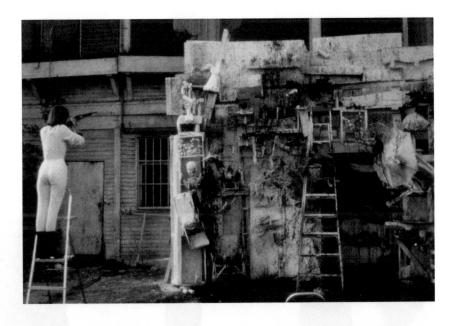

including Cage and Rauschenberg, then moved on to the opening of Tinguely's exhibition of viewer-activated machines at the Everett Ellin Gallery down the block and then to the Dwan Gallery for Rauschenberg's opening reception. On the 6th, Kienholz's tableau, *Roxy's*, opened at the Ferus Gallery with boilermakers (bourbon with beer chasers) served to the visitors who had been invited to wear black tie.[13] The action-packed month ended with another Saint Phalle 'shooting event' on a Sunday afternoon in the Malibu Hills. In attendance were Hollywood and art world celebrities, including film star Jane Fonda and curator Henry Geldzahler. Before the shooting Jane Fonda organised a picnic for the director John Houseman, and invited art critics, artists, models, and film and theatre personalities. Saint Phalle systematically shot at a huge assemblage embedded with ink bottles and dominated by a dinosaur skeleton and a bird cage containing a live bird. The rifles were lent

[9] Niki de Saint Phalle's shooting
in the Malibu Hills, end of March/
beginning of April 1962.

by Kienholz and a certain tension would certainly have been created by the presence of the live bird. The event ended with a cannon built by Tinguely exploding yellow smoke.[14] The work was bought by gallerist Virginia Dwan and installed on the end wall of her swimming pool with Tinguely's cannon chained to it *(fig. 9)*.[15]

In New York, after their successful exhibitions in Los Angeles, Tinguely, Saint Phalle and Rauschenberg were keen to work together again. Saint Phalle asked Kenneth Koch, a New York poet whom she had met in the 1950s through her first husband, the writer Harry Mathews, to write a script for them.[16] Koch approached John Wulp, who had recently produced Koch's one-act play, *George Washington Crossing the Delaware*, with the idea. Dancer and choreographer Merce Cunningham was persuaded to direct, and the Stewed Prunes, a comedy act, served as the onstage chorus. The building of a city was to

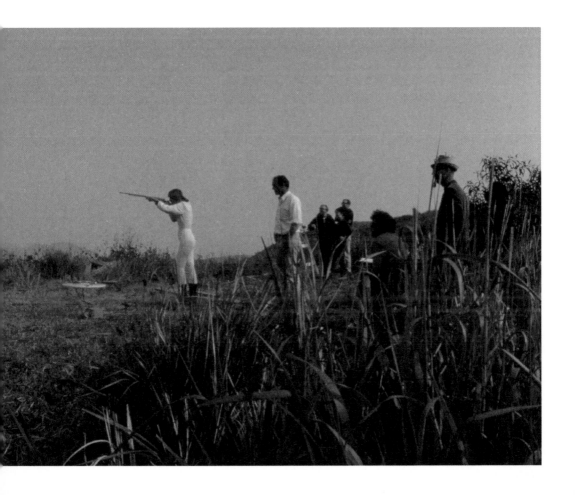

be the subject, with Rauschenberg responsible for providing people and weather; Tinguely, urban architecture; and Saint Phalle, culture. *The Construction of Boston* was performed on 4 May to a full house.[17]

Saint Phalle's work in this production is of particular interest (*fig.* 10). When the Stewed Prunes called for Saint Phalle to provide culture for Boston, she entered down the centre aisle dressed in the uniform of a Napoleonic artillery officer while a plaster cast of the *Venus de Milo* was wheeled onstage. Saint Phalle was handed a rifle and began firing at the sculpture, which bled red, green and brown paint from the face and chest, turning an ideal representation of femininity into a 'murdered', paint-spattered corpse. A cannon was brought out that was to have sprayed the *Venus* white again, but it accidentally backfired and almost fell into the audience. Saint Phalle's dual role of bringing culture and war to Boston and the resulting shot sculpture are

[10] *Venus de Milo*, Jean Tinguely and Niki de Saint Phalle, after *The Construction of Boston*, Maidman Playhouse, New York, 4 May 1962.

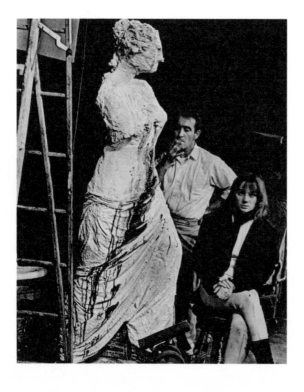

incredibly powerful. The figure of Venus – a symbol of ancient culture, a symbol of the Louvre, a human figure, a woman/goddess – provides a rich array of associations and possible interpretations for the viewer: the destruction of an ancient culture to be replaced by a new one; a break with the past to create a new future (like the symbolic nature of the Boston Tea Party). The shooting itself and the use of a cannon could be read as a reference to Duchamp, as could the practice of making a work your own through the addition to a reproduction of a pre-existing artwork, such as Duchamp's famous *L.H.O.O.Q.* (1919, the Mona Lisa with a moustache and goatee).[18] The shooting of a national (French) cultural institution by the Franco-American Saint Phalle could also be read as an attack on nationalism. Although dressed as a French army officer, she is also a young, female, avant-garde artist – shooting at the 'institution of art' and the power that it wields, and possibly its exclusions.[19]

Based on a parody of male aggression, the attack on the body of woman, on the feminine myth of beauty and perfection, could be read in the context of Saint Phalle's performance as an appropriation of power, as a woman responsible for both creation and destruction, life and death; it may equally be seen as the acceptance of male violence and female helplessness. Saint Phalle has described her target assemblages as a symbolic act of protest and liberation against the image of woman imposed by contemporary society. Saint Phalle's own complicity in reinforcing that unattainable ideal as a model in the 1940s and 1950s further complicates the attack – is she shooting at herself, at her past (*figs.* 11, 12)? The focus on the female figure and its representation in art presages both the imagery and locus of feminist discussions about art of the 1970s, and Saint Phalle's own later works, the *Nanas*.

The event was a resounding success and the group talked excitedly of working together again in the future; and so they did, a few months later in Amsterdam. The 'DYLABY (Dynamic Labyrinth)' exhibition at the Stedelijk Museum (30 August–30 September) brought together Rauschenberg, Saint Phalle, Tinguely, Raysse, Spoerri and Per Olof Ultvedt. This was another theatrical experience for the audience, as the artists turned seven rooms into different multi-sensory environments. Saint Phalle's room was a shooting gallery in which bags of paint were hung with string in front of a large white relief of monsters to be shot at as if in a fairground game.

Another particularly powerful and thought-provoking work of the same year is *O.A.S.*, which was made by Saint Phalle for a solo exhibition at the Galerie Rive Droite, *Art moral, art sacré*, organised by Pierre Restany (15 June–15 July). While referring to *oeuvre d'art sacré* (work of sacred art), it could also be read as a specific reference to the Algerian war and as a denunciation of the hypocrisy and aggression of the O.A.S. (*Organisation de*

l'Armée Secrète, a far right terrorist group that supported the French occupation of Algeria), and their bombing campaign in Paris a few months before the exhibition.[20] It also called to mind the OAS's (Organization of American States) barring of Cuba at the request of the US on 30 January 1962. On a more universal level, the collision of religious and military iconography provides a powerful commentary on the number of wars that have taken place, and that continue to take place, in the name of religion.

Another shooting piece with political overtones, made in 1962–3 is *Head of State, Study for King Kong*. The assemblage is made of heads of various politicians – Lincoln, Washington, Kennedy, Castro, De Gaulle, Khrushchev – and Santa Claus and Donald Duck. It is laid out like a fairground game – shoot the politician – providing a harmless way of enacting revenge upon those responsible for the Cold War. It aptly captures the tension of the period when

[12] Niki de Saint Phalle on the cover of *Life* magazine, 26 September 1949.

[11] Niki de Saint Phalle preparing *Tir*.

one recalls that the Cuban missile crisis had only been resolved at the last minute on 28 October 1962 and that the diplomatic 'hotline' between Moscow and Washington, DC, was not yet in operation.[21] At a time when disarmament talks were 'on' one minute and 'off' the next, Saint Phalle's piece appears as an ultimatum – 'get around the table and start talking or I'll shoot'. It also seems to query the 'reality' of politics and politicians in a period of constantly changing alliances, by the association of Kennedy, Castro, De Gaulle and Khrushchev with the fantastical or 'unreal' characters of Santa Claus and Donald Duck. For an American viewer, it could recall the Mount Rushmore monument and conjure a sense of indignation that Khrushchev, De Gaulle, Castro, Santa Claus and Donald Duck should be included alongside the American heroes. Viewed after Kennedy's assassination in November 1963, the work acquires a particularly gruesome, eerie, premonitory quality.

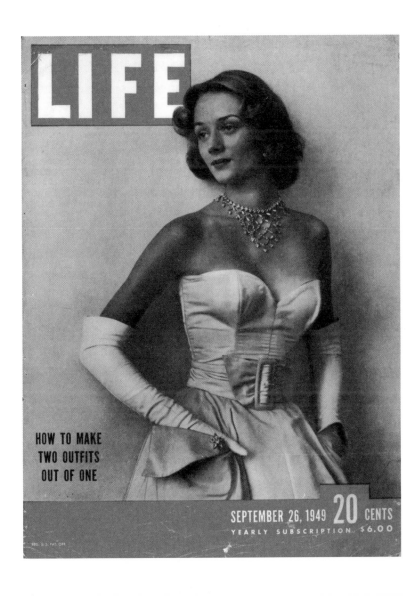

As Maurice Berger has observed, 'Saint Phalle was clearly commenting on the machismo and militaristic aggression that shapes the dynamics of masculine power. But her shooting galleries also introduced an element of anarchistic fun into the experience of art.'[22] These elements are clearly visible in her shooting artworks as a whole and this work in particular, where Saint Phalle has taken the gun from those who threaten world peace and turned it back on them. Of her shooting works she said, 'I was getting a kick out of provoking society through ART. No victims... I was shooting at my own violence and the VIOLENCE of the times.'[23] Thus this is both a statement on the times and an expression of violence that would be unacceptable in a woman, made possible through art, a victimless crime. Later revelations that Saint Phalle was shooting at her abusive father provide another reading of her shooting works and highlight the therapeutic or cathartic aspect of much *Nouveau Réaliste* work and its emphasis on 'creative destruction'.[24] At the time, Saint Phalle described the work as 'joyful... [a way in which] the result of a destructive act becomes positive'.[25]

The year closed with Saint Phalle's first solo exhibition in New York at the Alexander Iolas Gallery (15 October–3 November). It had been an extraordinary couple of years for Saint Phalle in which the self-taught artist had firmly established herself as a professional with an international reputation. More than twelve shootings had been held in Europe and the USA; her work had been included in major exhibitions and events in France, the Netherlands, Sweden, Denmark, Spain, Italy, Switzerland and the USA; and it was featured in over fifty international publications during 1961 alone. The years 1961–62 not only heralded Niki de Saint Phalle's spectacular entrance onto the world art scene but also the concerns and practices that would preoccupy her as her career evolved – the emphasis on the female form and the role of women in society, the engagement with socio-political issues, the multi-disciplinary and collaborative aspect of much of her work and the progression to large-scale permanent installations in which she continued these explorations, as well as addressing the relationships between art and life, art and the environment, and art and nature.

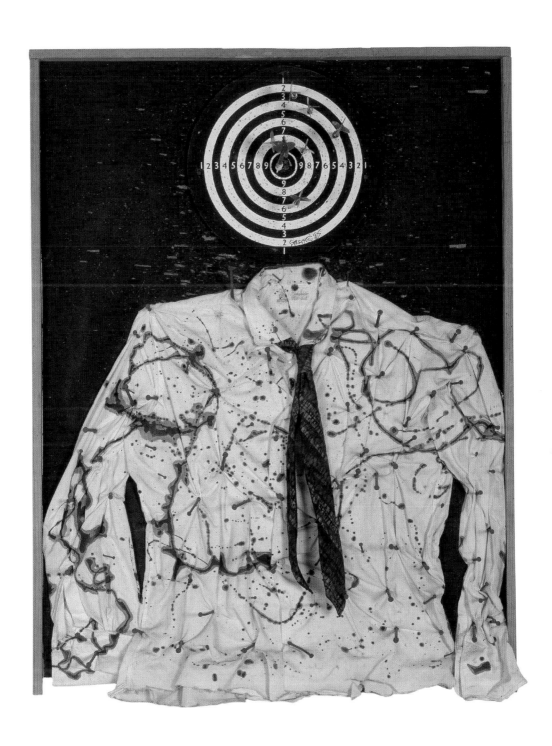

Saint Sébastien
(Portrait of my Lover)
1961

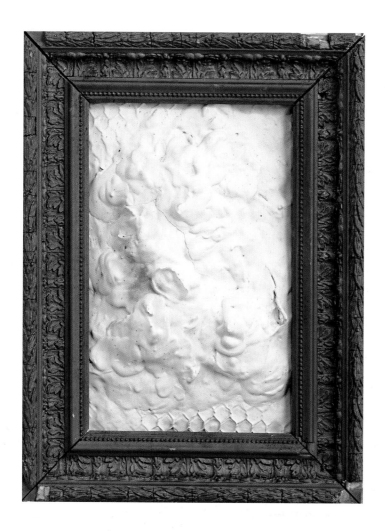

Old Master (non tiré)
c. 1961

62, 63

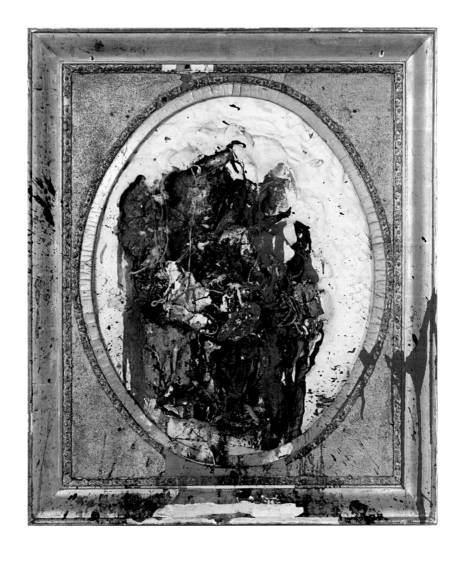

Old Master – séance Galerie J,
30 June – 12 July 1961
1961

Hommage to Bob Rauschenberg
(Shot by Rauschenberg)
1961

Shooting Painting American
Embassy 1961, Paris
1961

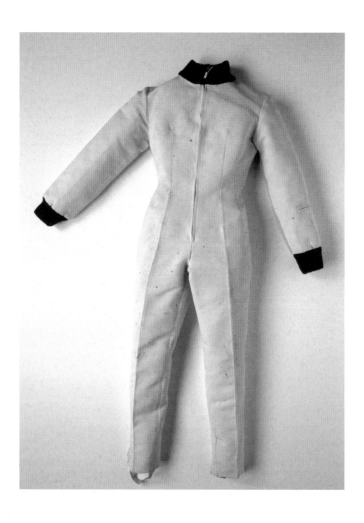

Shooting suit
1962

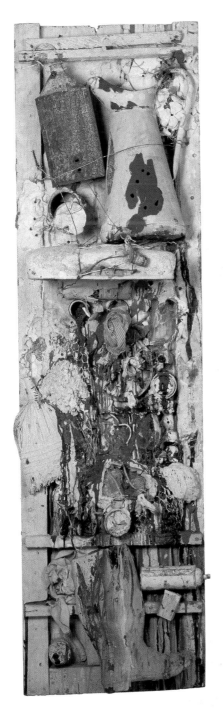

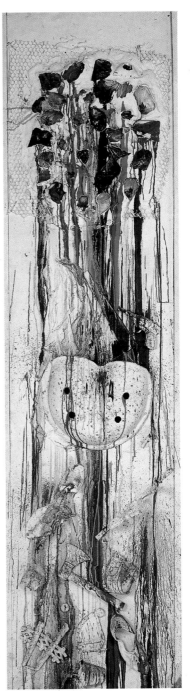

Shooting Picture: Tirage
1961

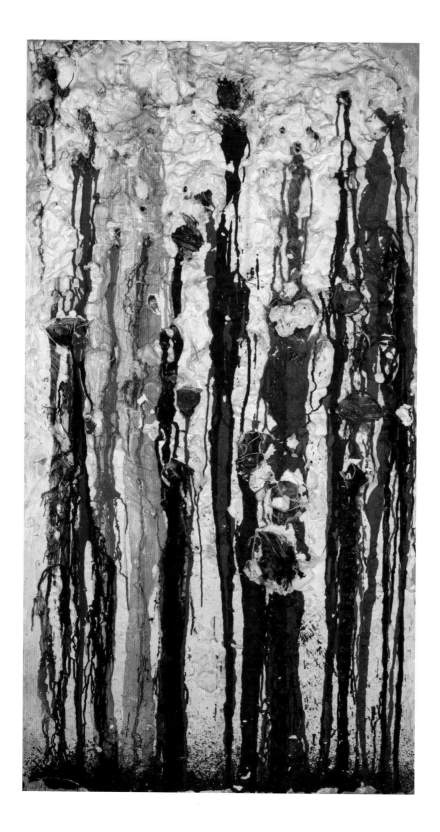

Grand Tir, séance Galerie J.
1961

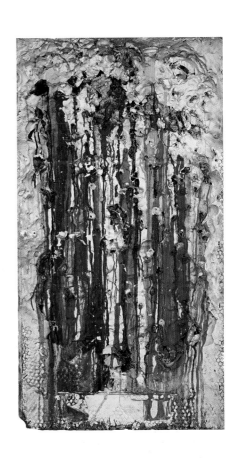

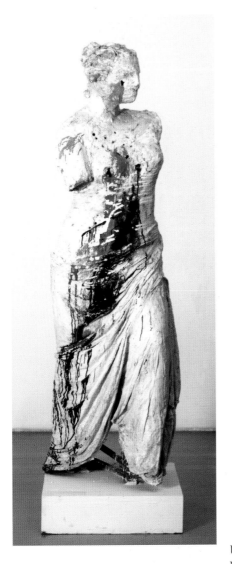

Vénus de Milo
1962

Heads of State
(Study for King Kong)
1963

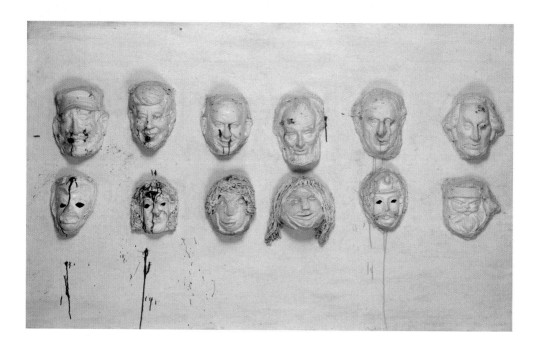

68, 69

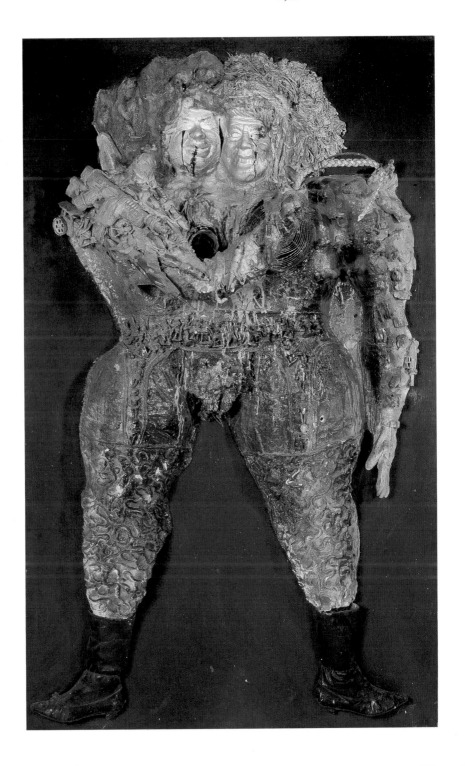

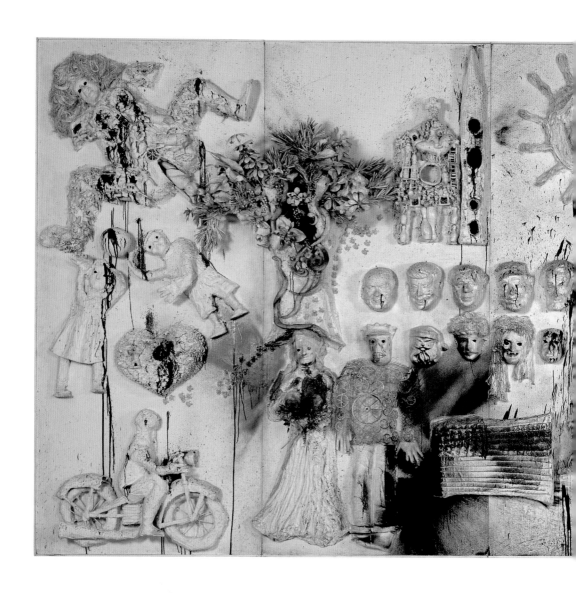

King Kong
1963

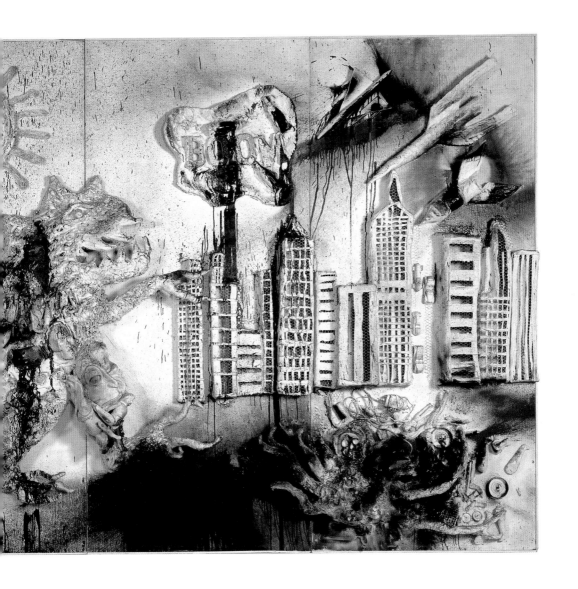

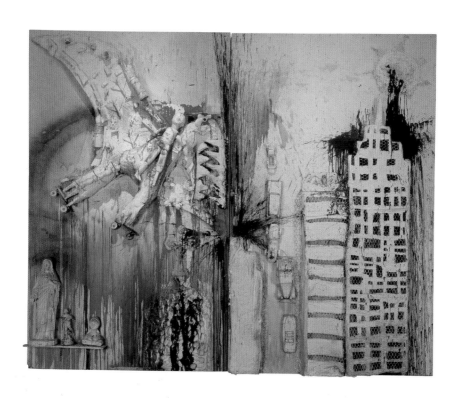

Pirodactyl over New York
1962

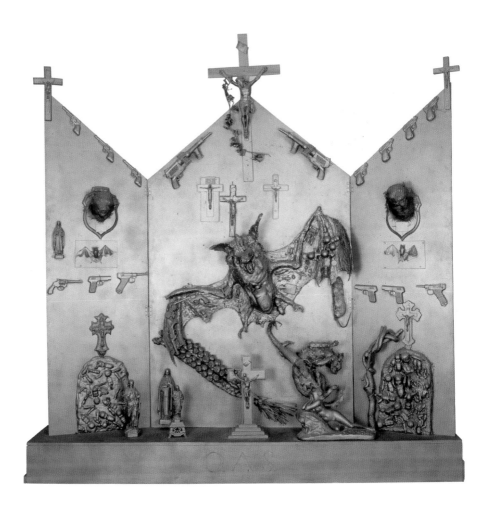

Autel O.A.S
1962–92

La Mariée à Cheval
1963–67

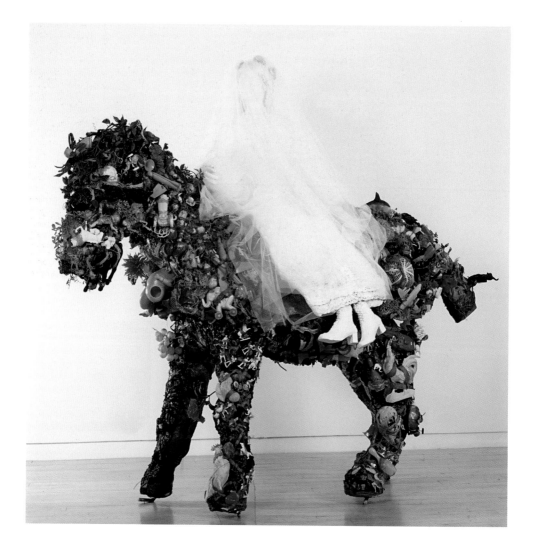

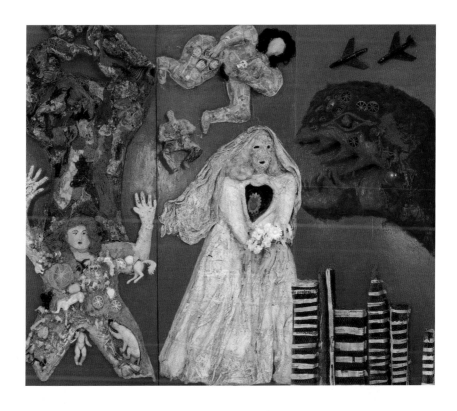

Autel des femmes
1964

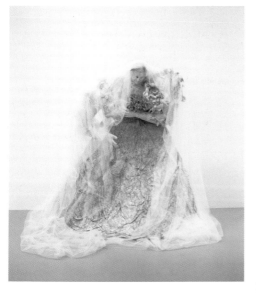

The Bride /
Miss Haversham's Dream
1965

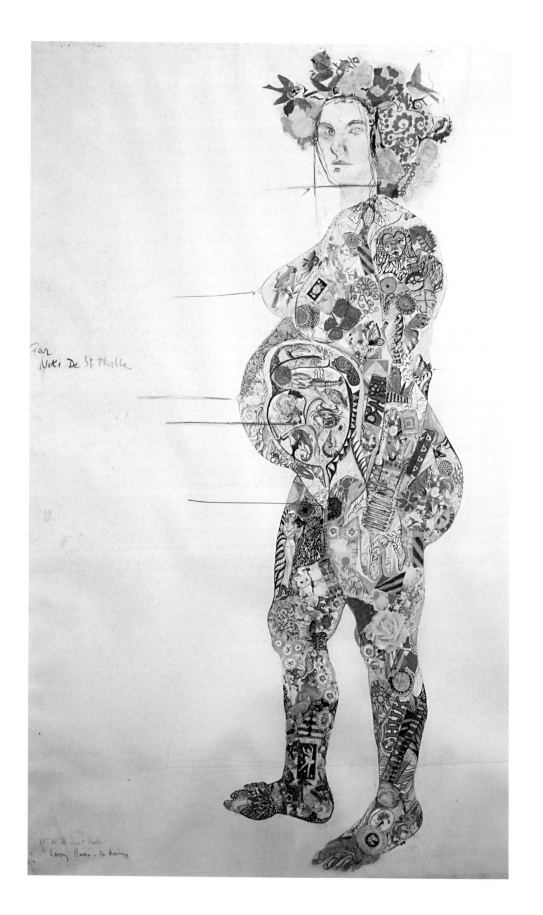

Par
Niki De St Phalle

Niki as Nana

BARBARA ROSE

[1] *Clarice Rivers* 1964
Collaboration between Niki de
Saint Phalle and Larry Rivers,
who drew the face for her collage.

IT WAS RAINING IN PARIS on the day in November 1961 when I met Niki de St. Phalle. I was lounging around the Galerie Lawrence on the Rue de Seine chatting with my friend Elizabeth de St. Phalle *(fig. 2)*, the wife of Larry Rubin, the owner of the gallery where my husband Frank Stella was showing his "Benjamin Moore" striped paintings. I was studying the black suede ankle boots Liz, the epitome of Parisian chic, was wearing, when a young woman wearing the same little boots breezily entered the deserted gallery. She was blonde and blue eyed with classically chiseled French features like Liz and perhaps even more strikingly beautiful – if that were possible. Liz introduced me to her older sister Niki, an artist whose work I already knew since she had created a considerable sensation as the only female member of Pierre Restany's legendary *Nouveaux Réalistes*, the French equivalent of the British and American pop artists.

The St. Phalle sisters were two of the most fascinating, charming, funny, generous, honest women I ever knew. I was totally enchanted by them. Niki and I immediately found lots in common. She invited me to visit her and her companion, kinetic artist Jean Tinguely, at their studio in the Impasse Ronsin. At that time the Impasse Ronsin was famous because Constantin Brancusi, who died in 1957, had had his studio there. (At that time it was still intact; later a reconstruction would become part of the Centre Pompidou.) The Impasse was a dead end, basically an alley, off the Rue de Vaugirard on the left bank in the 15th arrondissement. Tinguely had moved there in 1955 with his then wife, Eva Aeppli, a fellow Swiss artist.

Niki met Tinguely in 1956 while she was still married to the American writer Harry Mathews, though she and Mathews had already separated by that time. Fascinated by the man and his work, she asked Tinguely to make a metal armature for a sculpture she was working on. In 1960 Eva moved out of the Impasse Ronsin and Niki moved in with Tinguely, who I think was the love of her life, as well as her collaborator and co-conspirator.

The Impasse was a bustle of chaotic activity. Larry Rivers and his young Welsh wife Clarice had just arrived and there were a number of other artists who shuttled between Paris and New York. Yves Klein and Rotraut Ueuker celebrated their wedding there with a wild party hosted by Rivers in 1961. The official wedding portrait of the couple, with Klein in his formal costume of Rosicrucian grand master, was painted by Christo.

When I got there, the Impasse, with its variety of junk piles and shanties, resembled nothing more than a gypsy encampment. But even in the general disorder, the studio Niki shared with Tinguely stood out. There were enormous trash cans outside filled with garbage, which they apparently disposed of by burning. The odor was unforgettable. Inside, there was "stuff" – all kinds of stuff that might at any moment be appropriated as material for Jean's assemblage

constructions. By this time, Niki too was creating a highly original form of sculpture of hollow plaster nudes – all female as I recall, although I later learnt that they weren't and she was hooting they weren't female figures yet, but rather an "assemblage," which is the term she used – which she stuffed with plastic bags filled with liquid paint. The plaster figures were doomed to a tragic destiny since Niki would destroy them by shooting them, thus breaking the bags which squirted paint over the white surfaces, covering them in colored goo that resembled blood.

At the time she was doing her first performances, the *Tirs*, in which she lined up the figures as in a shooting gallery and took aim at them with her rifle. When she shot them in public she wore a white jumpsuit that was somewhere between an equestrian's and an astronaut's outfit *(fig. 3)*. She must have designed it herself. She had a natural talent for fashion, to the extent that designers followed her style. She was the first to wear long skirts, for example,

[3] Niki de Saint Phalle during her first shooting action in the United States, sponsored by the Everett Ellin Gallery, Los Angeles, 4 March 1962: Niki de Saint Phalle and Jean Tinguely.
PHOTO: Seymour Rosen

[2] Elizabeth de Saint Phalle Rubin at Galerie J, 1961.

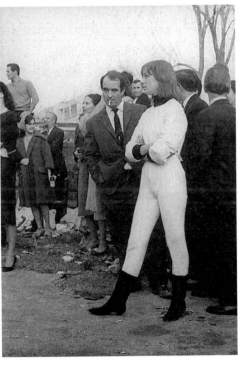

when everybody else was running around in minis. The following season, they were on the Paris runways. Marc Bohan, who was at that time the designer for Dior, was indeed a friend of Niki's and later made some dresses and hats for her. Many of the most gifted Parisians were also friends, like the scientist Etienne Baulieu, whose sword Niki and Jean designed when he was made a member of the Academie Française.

Niki knew lots of people but she had no stereotypes or social ambition. The daughter of an aristocratic banker and descendant of a medieval French knight, she was an artist among artists who spent the better part of her life with the son of a maid and a worker in a Swiss chocolate factory. When we met, her circle included, besides her sister Liz, Larry Rivers and his wife Clarice, Jasper Johns and Robert Rauschenberg *(fig. 4)*, various poets and writers, and the eccentric Greek gallerist, Alexander Iolas, who became her Maecenas, introducing her to people like Princess Marina of Greece, who was also a painter.

Surrounded by debris, Niki and Jean were like a couple of kids in a sandbox, inventing imaginary worlds and fantastic structures. Their playfulness was perhaps a *folie à deux* – after all somebody is supposed to grow up – but it was irresistible. I know no one who disliked them, although some were terrified by Niki's unpredictable fearlessness. You really did not know what she was going to do next, and neither did she. Jean gave her the approval and support, plus the engineering only men could do at the time, that made her large-scale mature work possible.

Frank's show at the Galerie Lawrence was not exactly an outstanding success. Outside of Niki, Arman – who also showed at the gallery – and the painter Poliakoff, the only other people I can remember seeing the show were the poet John Ashbery, at the time the art critic of the *Herald Tribune*, and the collector Joseph Hirshhorn. John was kind in his review, calling Frank's colors "bright but cheerless like a package of Charms." Hirshhorn, on the other hand, refused to buy a painting despite my assurance that my husband was the greatest painter of his generation. Instead he offered to send a case of champagne up to our suite because we were just married. (We signed the registry in London right after Clarice and Larry Rivers.) Niki and Liz were in the gallery when I told Hirshhorn that my husband didn't drink – I left out the part about the "suite" being a fifth-floor *chambre de bonne* without a bathroom – but that I needed a winter coat. Hirshhorn flipped open his wallet bulging with $100 bills and peeled one off and gave it to me. I ran over to Galeries Lafayette and bought a black wool coat, and still fixated on the St. Phalle sisters' little black suede booties, I had enough left over to buy a pair of them, too.

After the show, Frank and I went back to Spain where I had a Fulbright. We had applied for Fulbright scholarships together, deciding to

[4] Niki de Saint Phalle and
Jasper Johns during the vernissage
of 'Feu à Volonté', 1961.
PHOTO: Harry Shunk

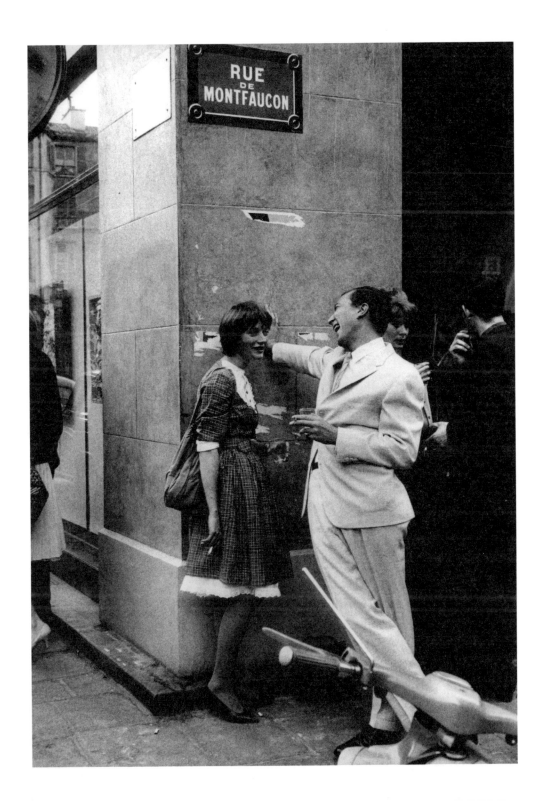

go to whichever country gave one of us the grant. Frank did not get a Fulbright to Japan, so we went to Spain. I didn't see Niki again until I came back to New York from Pamplona in March 1962. I was pregnant and I was not about to have a baby in Europe. Frank was renting the second floor of his studio at 84 Walker Street near Chinatown to Virginia Dwan, whose gallery in L.A. was home to the international avant-garde. I was surprised to find that half of them were living with us. Frank and I occupied the first floor. The building had no heat. The furniture consisted of a double sleeping bag on the floor. Niki and Jean, who lived on the second floor, were just back from L.A. where they had seen Simon Rodia's "outsider art" construction, the Watts Tower, which became an example for Niki of what an untrained artist could do out of sheer obsession.

One night I heard what sounded like gunfire. Frightened, I asked Frank to go see what was going on. He came back, zipped himself back into

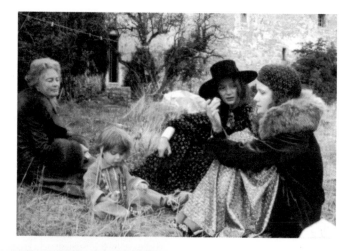

[5] Niki de Saint Phalle with her mother Jacqueline, her daughter Laura and her granddaughter Bloum, c. 1973/74.
PHOTO: Laurent Condominas

[6] Niki de Saint Phalle and her son Philip, c. 1958/59.

the sleeping bag and groggily told me it was just Niki shooting the rats as they came out of the corners of the studio. Given how much garbage Niki and Jean managed to accumulate, this wasn't surprising.

In May Niki and Jean staged Kenneth Koch's play, *The Construction of Boston*, at the Maidman Theater. There was considerable role playing and role switching, with Henry Geldzahler playing Tinguely. Frank in a hooded slicker played Rauschenberg, who was also onstage in another hooded slicker. Jean, dressed in a ball gown, wheeled in a pile of cinder blocks and dumped them so close to the edge of the stage that some fell over into an audience including Marian Javits, the wife of the New York senator. At one point Niki shot a plaster Venus de Milo filled with runny paint. The show was a sold out *succès de scandale* and the delight of the media.

By this time I was so sick and so pregnant that Leo Castelli gave us enough money to move to a walk-up, once again on the fifth floor, the size of a phone booth, which had heat and both a bathroom and a kitchen. When both Frank and Jean were out of town doing guy things, I invited Niki to dinner, and attempted to prepare boeuf bourguignon, which was a farce since I couldn't cook – but then again neither could she. I needed to talk to Niki about girl stuff. She was the only woman I knew in the art world who had children and I needed advice since I was totally terrified of giving birth (*figs.* 5, 6). The idea of the excruciating pain of delivery was really frightening. Niki laughed and said she was much crazier than I was and she had managed to have two children. Then she told me in graphic terms about the birth of her son in Mallorca, where they refused to give her anesthesia and shackled her to the bed so she could not move. She assured me things would be much easier in New York.

Niki gave me the courage I needed. In many ways she was a role model I could identify with, a woman who lived and worked in a man's world without compromise or complaint. I felt less scared about childbirth because Niki was right, she was crazier than I was and if she could do it, then I could, too. She told me about her total nervous breakdown in 1953, how she had been hospitalized and given shock treatment and how she started to make art, which she signed "Niki Mathews," as a kind of therapy that permitted her to express her fears and rage.

Her inspiration for being an untrained artist, in addition to Simon Rodia, was the postman Joseph Ferdinand Cheval, whose *Palais ideal* in the village of Drome, France, she had seen with Harry Mathews in 1956. The idea that naïve and outsider art had vitality, spontaneity, and authenticity gave her a point of departure independent of avant-garde strategies and conceptual connivances. In fact she always considered herself an "outsider"

artist, which permitted her to create a totally personal world, uninhibited by the narrow criteria of modernist art or academic shibboleths.

When my baby Rachel was born in late June, Niki was in Europe where she exhibited ten *Tirs* (shooting paintings) and altars in Paris. Alexander Iolas, who specialized in Surrealism, was impressed and offered her an exhibition at his New York Gallery in October. Niki's first solo exhibition at Iolas's Gallery included her *Homage au Facteur Cheval*, a shooting gallery where the public was invited to participate in the spirit of Duchamp, whom Niki knew, and to shoot at the work, thus exorcizing their own repressed violence. The idea of art as catharsis, which saved her from the madhouse, remained with Niki all her life.

While Niki prepared her Iolas show, Jean would babysit so Frank and I could go out for Chinese food. Niki and Jean loved to go to Canal Street and come home with enormous quantities of mass-produced junk. I remember

[7] Niki de Saint Phalle
surrounded by her Nanas
in her studio in Soisy, 1966.
PHOTO: Harry Shunk

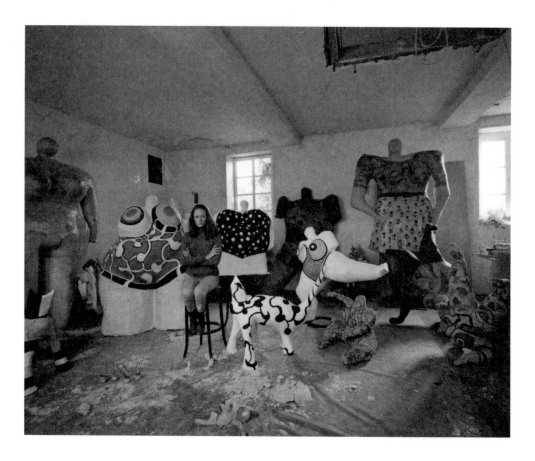

particularly Halloween 1962 when they returned thrilled with what looked to me like thousands of paper skeletons. I have no idea what they did with them, but they were fascinated with their moving parts and multiplicity. After Niki's show in Los Angeles at Virginia Dwan's gallery, where Ed Kienholz helped her construct the monumental sculpture *King Kong* that she blew open by shooting, they moved back to France and bought an abandoned inn, the Auberge de Cheval Blanc, in the country outside of Paris near Essonne in Soisy-sur-Ecole. It became their base, although they continued to travel to show their work. Jean by this time was considered an avant-garde master, but Niki was becoming more and more known as a serious artist with a scary fairytale repertoire of brides, mutilated beauties, and menacing beasts *(fig. 7)*.

In 1964 they came back to New York and lived in the Chelsea Hotel. Niki saw lots of Clarice Rivers who became pregnant in 1965 *(fig. 8)*.

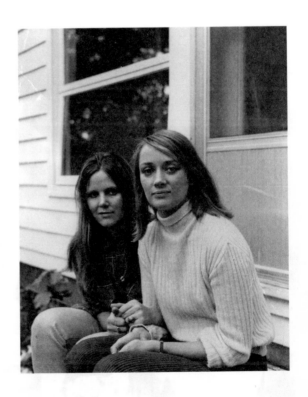

[8] Niki and Clarice Rivers,
Southampton, 1965.
PHOTO: Harry Shunk

Clarice and Larry had a house in Southampton, Long Island, where they spent the summers. That summer Niki joined them, creating her first Nanas, inspired by Clarice's pregnancy *(fig. 1)*, from *papier mâché* and wire netting, materials that Larry was experimenting with at the time as well. In the fall, she showed the Nanas at Iolas's gallery in Paris. The word Nana had a number of associations that appealed to her: Nana was Zola's *demimonde* prostitute and in current French *argot* the word corresponded to broad or chick. A nana was the opposite of a well brought up "nice," girl in other words.

From the beginning, the Nanas, who became an expanding population, had tiny heads and voluptuous fertility goddess bodies with bulging breasts, buttocks, and bellies. Their forms resembled the cavorting bathing beauty blimps in Picasso's beach paintings of the 1930s. The metaphor was obvious but timely: women were perceived as brainless sex objects, child-bearing

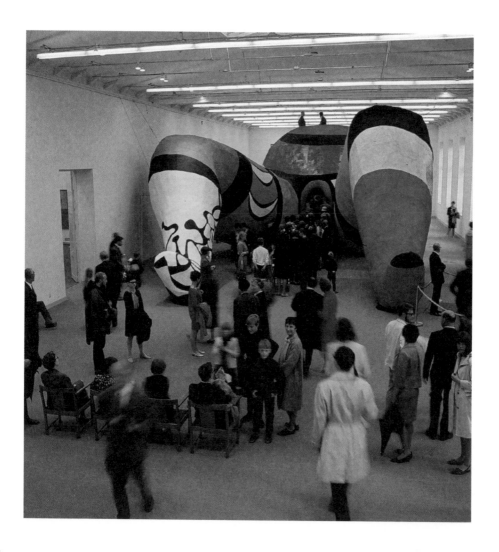

machines. The Nanas became increasingly sophisticated. Soon Niki was covering their hardened plaster casts with coats of polyester resin on which she could paint highly colored decorative motifs. And of course there were black Nanas as well as white Nanas. Many artists were experimenting with polyester at the time, but it was soon discovered that its fumes were toxic, deadly even, and they quit using the material. Knowing that the material could kill, Niki defiantly continued to use it.

In 1966 Niki created the mega-Nana, an immense architectural structure in the shape of a reclining woman in the position of giving birth, placed at the entrance of the Moderna Museet in Stockholm. It was called *Hon* – Swedish for 'her' – and its gaping vagina became the entrance passage to the museum *(figs. 9, 10)*. Certainly Dalí's sculpture installations were a precedent, and by that time Niki knew Dalí and his work. But she turned Dalí's

[9] *Hon* 1966
Visitors to the exhibition.
PHOTO: Hans Hammerskiöld

[10] *Hon* 1966
A gentleman entering *Hon*
through the sexual orifice.
PHOTO: Hans Hammerskiöld

representation of woman as sex object inside out, forcing men to walk back into the birth canal and confront their secret horror of the female anatomy. There was a milk bar in one breast of *Hon* and the Nana also contained a small movie theater, a planetarium, an aquarium, and an art gallery filled with forgeries of modern masterpieces. This massive project (created in collaboration with Jean Tinguely and Per Ultvelt) launched Niki as a public sculptor.

In the late 1960s and early 1970s I was in Paris frequently, giving lectures, seeing shows, and visiting friends. One of the friends was Niki who continued to be an inspiration of courage, obstinate truculence, and anarchic refusal to be limited or defined by her gender. By now the Nanas were her mutant alter egos. They were everything she was not: fat, grotesque, and vulgar. She started making inflatable plastic versions of the Nanas as multiples to be sold in New York, but she was already getting sick, suffering serious breathing problems caused by inhaling polyester fumes and dust. Within a few years she would not be able to live in Paris and would retire to Soisy where she and Jean were married in 1971.

They really had no need for such a conventional ceremony but it was convenient for Niki to have a Swiss passport. Two years later Jean left her for a young Swiss woman pregnant with his child and returned to Switzerland. Niki never recovered from the separation. However, they continued to work together, never divorced, and Tinguely left her in total control of his life's work, which she retained until she could place the pieces in the Jean Tinguely Museum in Basel, Switzerland.

The late 1970s were a terrible period for Niki, although she never complained or stopped working. Jean was gone and her sister Liz, who she hoped to collaborate with setting up a Nana multiple industry, died in a car crash in New York. Once while Niki still had an apartment in Paris, I went to visit her. She was thinner now, dressed in a teal blue silk shirt with matching wool trousers. I asked her what the next fashion would be and she said "uniforms." There was a strange life-size white canvas rag doll of a woman slumped in a chair in the corner. I asked her who had made it and she told me it was a present from Tinguely's first wife, Eva. She always kept it around like a talisman. She had that tendency of never leaving anything behind, incorporating things into her life where they remained as memory.

After Tinguely left, she lived in Soisy where I went to see her. The inn was very simple but comfortable. She was pale and coughing and too ill to hide it. "Let's laugh," she said. "We need to laugh because I read that laughter can cure you of disease." So we laughed hilariously for half an hour at nothing. Afterward she said she felt much better. I think by that time she knew her lungs would not hold out.

She had already collaborated with Tinguely, who motorized her pieces, many times. In 1979 her friends, the princes Caracciolo, gave her a mountain near their family compound in Capalbio in Garaviccio in southern Tuscany. She spent the next twenty years of her life creating the first monumental sculpture park made by a woman. Niki had mentioned in an interview in the early 1960s that her dream was to make a sculpture garden based on the Tarot cards. She called it the Tarot Garden and designed buildings that corresponded to the 22 houses of the Tarot, a series of cards used since the Middle Ages to predict the future *(fig. 11)*. I went to visit her there in the early 1980s, and as I walked through the garden and explored the painted and mirrored and ceramic-encrusted houses, each a distinct size and shape, I realized the entire project was meant as a permanent expression of her undying love for Tinguely as much as her obsession with her work and making

[11] *Tarot Garden*
Tuscany, Italy

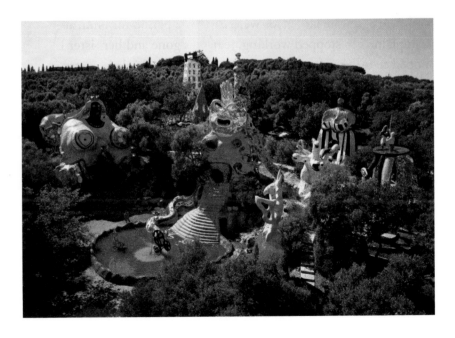

her dreams reality. She was inspired by Jean's *Cyclop*, but wanted to make something of her own. Later Jean got inspired by her and started working again on the *Cyclop* after Niki covered its face with mirrors (an obsession that started in the Tarot Garden). In the middle there was a tree with phrases written in Niki's familiar childish scrawl; one said, as I remember it, "Life is a game of cards whose rules we do not know."

In sorrow, she created delight *(figs.* 12, 13, 14). The broken ceramic tiles, mosaics, and mirrors, inspired by the Catalan art nouveau architect Niki had seen in Barcelona, sparkled with light, the monstrous grotesque anthropomorphics suggested by the Park of the Monsters at nearby Bomarzo. As the project progressed, Niki moved into the great head of the goddess, the Sphinx, which became her home for many year *(fig.* 15). Here she drew, painted, and planned the park which was constructed with a cadre of loyal assistants.

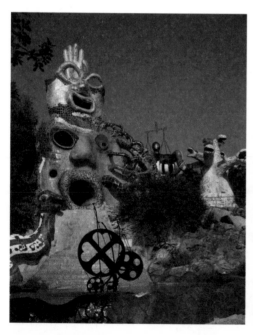

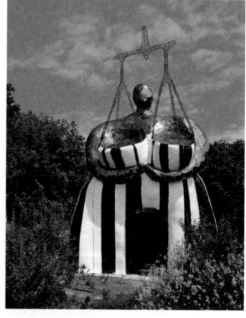

[12] *The Magician* (top),
The High Priestess (below)

[13] *Justice*

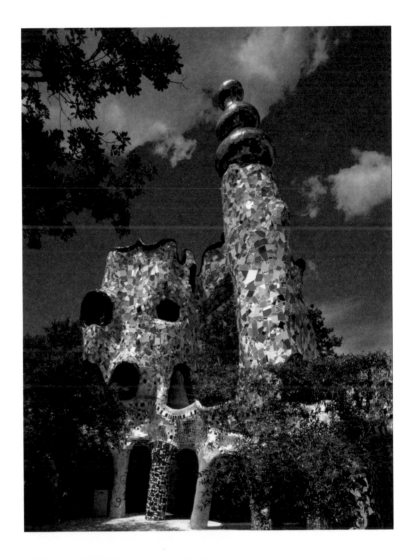

[14] *The Emperor*

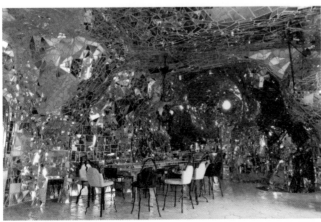

[15] *The Empress*

To pay for the project, she designed a perfume which sold well, scarves, ties, jewelry, and other decorative objects as well as a steady string of multiples. For despite her aristocratic lineage, Niki never had any money. Beginning with the Nanas, her work sold well and she was paid for commissions, but she spent everything on her work.

Niki's determination to finish the vast project of the Tarot Garden kept her going despite crippling rheumatoid arthritis and deteriorating lungs. The incredible inventiveness, the delights and surprises she created, are a permanent monument to her will to create, to survive, and to love, despite the traumas she described in her films and books. When Jean died in 1991, he was given a full state funeral in Basel. Niki, still legally his wife, walked at the head of his cortege, accompanied by his first wife, Eva Aeppli, and their children as well as his other children. Niki did not rest until she had the documents creating the Tinguely Museum signed.

Her health was clearly deteriorating and in 1994 her doctors insisted that she live in a warmer place and she moved near the beach in La Jolla, Southern California, where she continued to work on parks and public sculptures. Four years later the Tarot Garden was opened to the public. I tried to see her in La Jolla but was told she was too ill to see me. The last time I saw her she said her deepest regret is that she had never had a retrospective in the United States, since she had lived there half her life and had an American mother. She felt, she said, very American.

After a long illness, she died in California of asthma emphysema. She had dedicated her last great series of *Tableaux Eclatés* (exploding pictures), which disintegrate into their separate parts and then recompose, to Tinguely, immediately after his death, in what could only be interpreted as a metaphor for redemptive union. Since her death in 2002 at the age of 71, her reputation has grown, and more serious discussion of her work has taken place. But she has yet to realize her dream of an American retrospective.

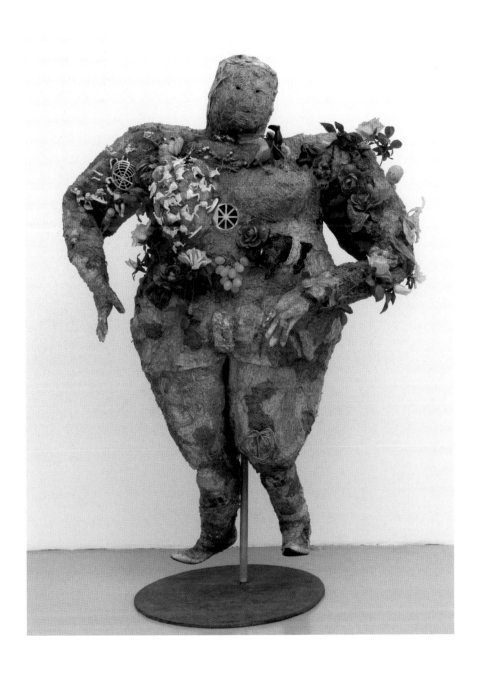

Vénus
1964

Nana Noire Upside-down
1965–66

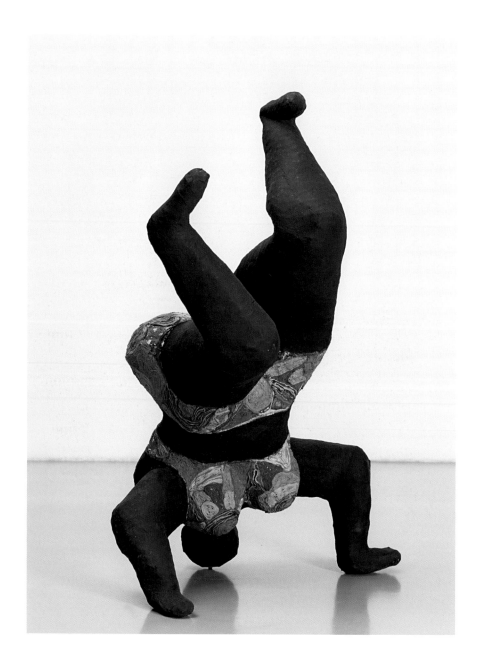

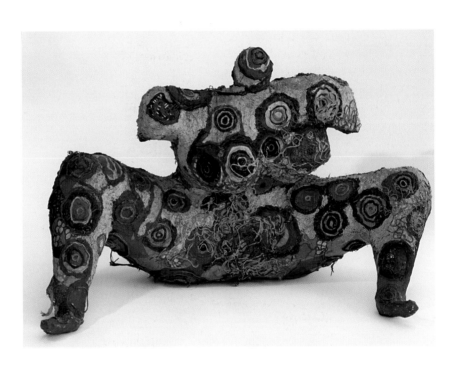

Nana Écartelée
1965

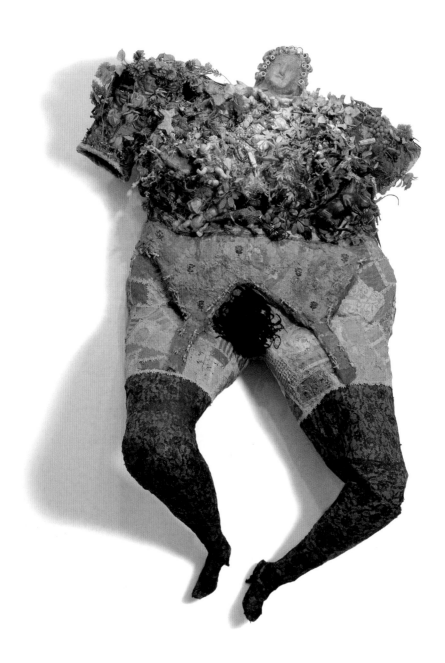

Crucifixion
c. 1965

Black Rosy (My Heart
Belongs to Rosy)
1965

Erica
1965

*Dear Diana, I had a
marvellous time*
1969

Nana Power
1970

Sweet Sexy Clarice
1968

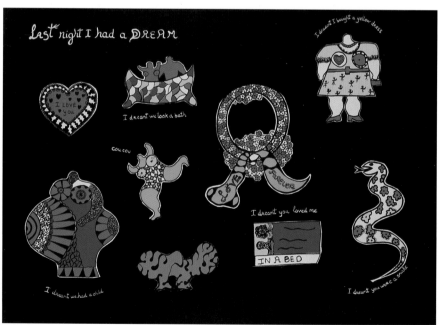

*What do you like about
me most?*
1970

Last night I had a dream
1968

Nana Power
1970

BLACK
is DIFFERENT.

I have made MANY
BLACK FIGURES
in my WORK.
BLACK Venus, black MadoNNa,
BLACK MEN, BLACK NANAS.
It has always been an important
coloR for me.
 Today, walking on the beach
 I watched a small black child
5 or 6 years old playing with his father.
He was So CUTE. It was
a REVELatioN.
 Black is ALSo ME Now
with my great grandson Djamal. This is NEW
and I like it.
 Djamal is FRENCH, American Vietnamese,
Greek, Belgian, Irish, English, African,
 Scottish, Russian, Italian, Jewish, Cuban.
 = AMERICAN
Black is also Me Now. Niki de Saint Phalle

ar Diary,
..inoeD me of a great PAGAN GoDess

Tarot Garden
1991

L'estrella
1997

The Falling Tower
1997

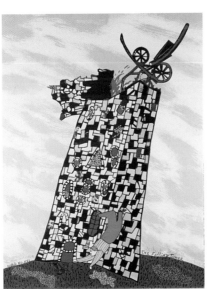

La Justice (Carte VIII)
1999

Nana Santé
1999

The Devil
1998

[1] *'l'image est peut- être le seul lien qui nous reste avecle sacré: avec l'*épouvante *que provoquent la mort et le sacrifice, avec la* sérénité *qui découle du pacte d'identification entre sacrifié et sacrifiants, et avec la* joie de la représentation *indissociable du sacrifice, sa seule traversée possible'*: Julia Kristeva, preface, *Visions Capitales*, Paris, Musée du Louvre, 1998, p. 11.

[2] *'Je n'ai jamais tiré sur Dieu... Je tire sur l'église. Je glorifie La Cathédrale'*: Niki de Saint Phalle, in *Niki de Saint Phalle*, Paris, Musée National d'Art Moderne, Centre Georges Pompidou, 1981, p. 17.

[3] See William C. Seitz, *The Art of Assemblage*, New York, Museum of Modern Art, p. 122. The 'family resemblances' evident in the catalogue which affiliate Niki's work with Surrealist objects, with Kurt Schwitter's Merzbau, with Simon Rodia's Watts Towers, and contemporaries beyond the *Nouveaux Réalistes*, from Parisian Yolande Fièvre to Enrico Baj in Italy, have implications beyond the scope of this essay.

[4] 'Niki' is in no way belittling; to repeat 'De Saint Phalle' (as one would say 'Bourgeois' or 'Hepworth') is both wordy and portentous.

[5] It was surely the poet John Ashbery's review of *Hors d'oeuvre* (shown at the Salon Comparaison no. 350), in the *New York Herald Tribune*, 8 February 1961, which generated Niki's American reputation.

[6] Gérard de Nerval, 'El Desdichado', in *Les Chimères – Poèmes de Gérard de Nerval*, 1854.

[7] *The New American Painting as shown in Eight European countries, 1958–9*, New York, The Museum of Modern Art, 1959. Paris was the last venue of the sensational tour.

[8] *'il y a à la fois du cow-boy et du werther dans cette histoire de pistolet... le geste de l'assassin ou du mari trompé devient un invitation au voyage...'*: Pierre Restany, 'Tir à volonté', Galerie J, 1961.

[9] *'dans un monde d'étranges merveilles où le sang cède la place au plus riches couleurs, où l'explosion suscite la forme neuve, où la blessure est poésie'*: Restany, 'Tir à volonté'. See Elienne Lawson, 'Pierre Restany, Janine de Goldschmidt and the Galerie J, 1961–66: The Art of Making Nouveau Réalisme', MA thesis, Courtauld Institute of Art, University of London, 2002.

[10] At the time of the first Paris Biennale des Jeunes of 1959, Tinguely's cranky 'drawing machines' created a sensation on the esplanade of the Eiffel Tower.

[11] *Posséder et détuire, les stratégies sexuelles dans l'art d'occident*, Paris, Musée du Louvre, 2000, told a story where the classical tradition gave way to Antonin Artaud, the Viennese Actionists and Yves Klein. Curated by Regis Michel, this erotic pageant was by no means challenged or deconstructed.

[12] Murielle Gagnebin, *Fascination de la laideur. L'en deça psychanalytique du laid* [1978], Lausanne, Editions Champ Vallon, 1994, p. 259.

[13] *'L'accouchement c'est la femme virile. Elle porte l'enfant comme un sexe masculin. Mes naissances font de la femme une déesse. Elles deviennent à la fois père et mère.* Anonymous: *Accoucher debout, dans un pré, comme la mère de Descartes! Quel discours! Quelle méthode! La femme virile de Niki nous laisse pantois, sans réponse'*: Niki de Saint Phalle, p. 44.

[14] See Sarah Wilson, 'Fêting the Wound' Georges Bataille and Jean Fautrier in the 1940s', *Writing the Sacred: Georges Bataille*, ed. Carolyn Gill, London, Routledge, 1995, pp. 172-192.

[15] 'Dames' were not ladies, but prostitutes, so-called with the chivalry of those who accepted the inevitability of the situation.

[16] See Marjorie Garber, *Vested Interests. Cross-Dressing and Cultural Anxiety*, New York, 1992, pp. 126-7 on female fetishism and fetish envy.

[17] The Sadean vogue was enhanced, of course, by the writings of Georges Bataille and Pierre Klossowski. For a discussion of Fini, see Jennifer Thatcher, 'Menace à Trois: the Art of Leonora Fini, Niki de Saint Phalle and Annette Messager in the Context of 1970s French Feminism', MA thesis, 1998. See also Sarah Wilson, 'Axell: One+One', *Evelyne Axell, from Pop Art to Paradise*, Paris, Editions Somogy, 2004 pp.23–40, and 'Rites of Passage: Myriam Bat-Yosef and Performance', *Myriam Bat-Yosef, Paintings, Objects, Performances*, ed. Fabrice Pascaud, Paris, Editions Somogy, 2005, pp. 92-107 (bilingual).

[18] Sartre's characterisation of the viscous as the sweet and feminine 'revenge of the en-soi' in *Being and Nothingness* was challenged by Suzanne Lilar in *A propos de Sartre et l'amour*, Paris, Grasset, 1967, p. 77. See also Dorothy Mac Call, 'Existentialisme ou Feminisme?', in 'Sartre', special number of *Obliques*, 1979, pp. 311–20.

[19] Niki's own mother, with her strict standards, high expectations and her condoning of her husband's infidelities, plays a significant role in *Traces. An Autobiography. Remembering 1930–1949*, Lausanne, Acatos Publications, 1999.

[20] The psychoanalyst D. W. Winnicott explored the concept of the 'good-enough' mother; his 1951 article 'Transitional Objects and Transitional Phenomena' appeared in *La Psychanalyse*, no. 5, 1959 (review of the French Society of Psycho-analysis founded by Jacques Lacan and Daniel Lagache). Winnicott became known to a wide French audience through a special number of the review *L'Arc*, no. 69, 1977. See also Mignon Nixon, 'Bad enough mother', *October*, vol. 71, feminist issue (Winter, 1995), pp. 70–92: 'Bourgeois subverts the name-of-the-father logic of Lacanian theory

through a destruction-of-the-father, part-object logic based in the Kleinian model.'

21 I refer to Julia Kristeva's 'Giotto's Joy' and 'Motherhood according to Giovanni Bellini' – inspired by the example of Marina Warner's *Alone of All Her Sex: The Myth and the Cult of the Virgin Mary*, London, Weidenfeld and Nicolson, 1976. See Julia Kristeva, *The Kristeva Reader*, ed. Toril Moi, Oxford, Basil Blackwell, 1986, and *Desire in Language, a Semiotic Approach to Literature and Art*, ed. Léon S. Roudiez, New York, Columbia University Press, 1980.

22 See Henri Alleg's torture exposé, *La Question*, Paris, Editions de Minuit, 1958, and Simone de Beauvoir and Gisèle Halimi, *Djamila Boupacha*, Paris, Gallimard, 1962, for the most notorious rape-case.

23 See Laurence Bertrand-Dorléac, '*La France déchirée*: Hains et Villeglé', in *La France en Guerre d'Algérie*, Paris, Musée d'Histoire contemporaine (BDIC), 1992, pp. 202–03 (referring to Jacques Fauvet, *La France déchirée*, Paris, Fayard, 1957).

24 Michel Leiris insisted on showing Guyotat's *Tombeau pour cinq cent mille soldats* (Paris, Gallimard, 1967) to Picasso. Guyotat's sequel, *Eden, Eden, Eden*, was banned by the French government from 1971 to 1981.

25 Compare 'bad' as in the exhibition *Bad Girls*; the Middle English representative of Old English 'baeddel' has hermaphroditic overtones; the derivative 'baedling' means 'effeminate fellow, womanish man'; but bad can be positive, Dionysiac, humorous. See Laura Cottingham, 'What's So Bad About 'Em?', in *Bad Girls*, London, Institute of Contemporary Arts, 1993 (for etymology see p. 59, note 2).

26 The commemorative Moderna Museet, Stockholm publication, *hon – en katedral*, with 'katedral' crossed out and replaced by '*historia*', recounts Niki's history, and the *Hon*'s construction, exhibition, press response and demolition; with comparisons from the Venus of Lespuge to the Statue of Liberty, art-historical studies and an extensive quotation from Sigmund Freud's *Interpretation of Dreams*.

27 See reprint of the two exhibition catalogues as *The Complete Book of Erotic Art*, compiled by Phyllis and Eberhard Kronhausen, New York, Bell Publishing Company, 1987.

28 See Grace Glueck, 'Tinguely's Machines Menace Niki's Nanas in the Park', *New York Times*, 2 May 1968; 'La "Nana-Maison" merveilleusement tatouée', *Beaux-Arts*, Paris, 4 May 1968; and *Le Décor quotidien de la vie en 1968, expansions et environnements*, Musée Galliera, April–May, 1968 (with Arnal, César, de Rosny, Sanejouand, Tinguely, Xenakis).

29 'le plus important artiste féminin de l'époque': François Pluchart, 'Merveilleuse Niki de Saint Phalle', *Combat*, 11 November 1968.

30 See Jill Carrick, 'Phallic Victories? Niki de Saint Phalle's "Tirs"', *Art History*, vol. 26, no. 5, pp. 700–29, an article focusing on the Milan anniversary in 1970 which elevates psychoanalysis at the expense of the sacred and the blasphemous.

31 Kristeva makes a direct link between frenzied rites around decapitated skulls and the incest taboo in *Visions Capitales*, p. 27.

32 Gilles de Rais was tried in 1440 for having violated, tortured and murdered 140 children over an eight-year period, during satanic rites. See Georges Bataille ed. and preface with Pierre Klossowski's translation from the ecclesiastical Latin, *Le procès de Gilles de Rais*, Paris, Jean-Jacques Pauvert, 1965.

33 Richard Roud, interview with Niki de Saint Phalle and Peter Whitehead, *The Arts Guardian*, 6 April 1973.

34 *Daddy – A Bedtime Story*, Argos films, 1972–3; transcription from video in St Phalle archives in Joanna Thornberry, 'Niki de Saint Phalle: Tirs and Transgressions', MA thesis, Courtauld Institute of Art, 1995, Appendix, p. 3.

35 Hicks exhibited *Je savais que si je venais un jour, j'y passerai mes nuits*, 1972, wool and bobbin-work on linen, 4.70 x 9 m; *L'épouse preferée occupe ses nuits*, 1972, an 'envelopement' of wool, 5.20 x 2.60 x .20m, artist's collection; in *Douze ans d'art contemporain*, Paris, Grand Palais, 1972, pp. 229–31; see also Sheila Strizler-Levine, *Sheila Hicks: Weaving as Metaphor*, London, Yale University Press, 2006.

36 *Moi? Une sauvage? Elle a trouvé enfin une réponse, qu'une femme dans la civilisation des hommes c'est comme un nègre dans la civilisation des blancs. Elle a droit au refus, à la revolte. L'étendard sanglant est levé.'* Niki de Saint Phalle, Galerie Alexandre Iolas, 1965, in *Douze ans de l'art contemporain*, op. cit., p. 302.

37 See T. Denean Sharpley-Whiting, *Black Venus: Sexualized Savages, Primal Fears, and Primitive Narratives in French*, Durham, NC, Duke University Press, 1999.

38 In *Art News* 68 (March 1969–February 1970), Nochlin cites two articles on women painters out of 81 major articles; in *Art News* 69 (March 1970–February 1971), ten out of 84 (nine, including Nochlin's own, in the special January women's issue); and in *Artforum* 1970–1 five out of 74 articles on women. See Linda Nochlin, 'Why Have There Been No Great Women Artists? Thirty Years After', in Carol Armstrong and Catherine de Zegher, eds., *Women Artists at the Millennium*, Cambridge, MA, and London, MIT, October Books, 2006, pp. 21–32.

39 For the Californian context see Meredith Brown, *School is a Place to Perform: The Art and Pedagogy of Judy Chicago's Women's Art Program at Fresno State College, 1970–1971*, MA thesis, Courtauld Institute of Art, 2007.

40 Maryse Holder, 'Another Cuntree: At Last, a Mainstream Female Art Movement' (*off our backs*, September 1973), in Arlene Raven, Cassandra Langer and Joanna Frueh, eds, *Feminist Art Criticism. An Anthology*, New York, 1991, pp. 1–20.

41 After the abortion debate in the early 1970s there followed the establishment of the MLF (Mouvement de la Libération des femmes) and the group 'Psych et Po' (psychoanalysis and politics); the periodical *Les Sorcières* ran from 1976 to 1982; *La Spirale* was launched in 1972; and *Féminie-Dialogue* was held at Unesco in 1977. Following a Paris visit in March 1977, Lucy Lippard would curate *Combative Acts, Profile and Voices*, at the A.I.R. Gallery, New York, including French feminist artists (but without Niki). See Thatcher, 'Menace à Trois,'op. cit.; the forth-coming PhD (University of London) by Rakhee Balaram, 'Femmes Révolutionnaires: Women's Art Theory and Politics in 1970s France'; Diana Quinby, *La collectif 'Femmes-art' à Paris des les années 70*, Paris-Sorbonne-1, 2003; and Marie-Jo Bonnet, *Le Femmes artistes dans les avant-gardes*, Paris, Odile Jacob, 2006.

42 Lea Lublin, 'Space Perspective and Forbidden Desires of Artemisia G.', in *Artemisia*, Mot pour Mot/Word for Word, 2, Paris, Galerie Yvon Lambert, 1979, pp. 51, 53 (bilingual, translation Diane Chrestien).

43 Louise Bourgeois, 'Child Abuse', *Artforum*, vol. 20, no. 4, December 1982, pp. 40–47, and cover.

44 Niki de Saint Phalle, *Mon secret*, Paris, Editions de la Différence, 1994 (written December 1992). See Thornberry, 'Niki de Saint Phalle', Chapter 1, and Natasha de Samarkandi's unpublished essay '*Mon Secret*, rereading Niki de Saint Phalle', with first translation of the text, Courtauld Institute, 2007.

45 Pontus Hulten, ed., *Territorium Artis*, Bonn, Kunst-und-Ausstellungshalle der Bundesrepublik Deutschland; Bonn, Verlag Gerd Hatje, 1992, English version. Niki's *King Kong* altarpiece (pp. 316–7) was exhibited in the show, together with two objects by Meret Oppenheim and one piece each by Jenny Holzer and Rebecca Horn.

46 Pontus Hulten, 'Working with Fury and with Pleasure', in *Niki de Saint Phalle*, Bonn, Kunst-und-Ausstellungshalle der Bundesrepublik Deutschland, 1992; English version, p.13. (The show toured to the Glasgow, McLellan Galleries and Paris, Musée de la Ville de Paris in 1993).

47 Barbara Rose, 'Earthly Delights', *US Vogue*, December 1987, p. 365.

48 See the superb catalogue *Niki de Saint Phalle & Jean Tinguely, L'art et l'amour*, 13 April to 24 June 2007, Centro Atlantico de Arte Moderno (CAAM), curated by Alvaro Rodrigues Fominaya, with a text by Bloum Cadenas (English translations).

49 See Niki de Saint Phalle, *Traces*, op.cit, 1999 and *Harry and Me, The Family Years, 1950–1960*, Bern, Benteli Verlag, 2006.

1 'Bewogen Bewegung' (Movement in Art) at the Stedelijk Museum in Amsterdam, Netherlands (10 March–17 April 1961), which travelled to the Moderna Museet in Stockholm, Sweden, as 'Rörelse i konsten' (17 May–13 September) and the Louisiana Museum of Modern Art in Humlebaek, Denmark, as 'Bevaegelsi i kunsten' (22 September–22 October).

2 *Télé 7 jours*, no. 57, 22 April 1961; see *1960 Les Nouveaux Réalistes*, Paris, Musée d'art Moderne de la Ville de Paris, 1986, p. 81.

3 Pierre Restany, correspondence with the author, 26 February 1998.

4 Tinguely met Rauschenberg and Johns in New York the previous year while he was working on his *Homage to New York* (17 March 1960). Rauschenberg made a work for the 'Movement in Art' exhibition. On 23 May 1961, while the exhibition was in Stockholm, Rauschenberg took part in a Saint Phalle shooting in Staket sandpit near Värmdö, Sweden. Rauschenberg and Johns were good friends of Cage and Tudor and had worked with them often since Rauschenberg met them at Black Mountain College in 1952. Rauschenberg and Johns met in 1954. Cage met Tudor in 1950.

5 Saint Phalle's action was considered a high-risk activity, so the Embassy insisted that she hire a professional sharpshooter as opposed to allowing her to shoot the work herself.

6 For more on the event see Amy J. Dempsey, 'The Friendship of America and France: A New Internationalism, 1961–1965', PhD thesis, Courtauld Institute of Art, University of London, 1999.

7 See Sarah Wilson, 'Public Enemy', *Tate*, 2, Spring 1994.

8 In Lilian Tone's chronology in Kirk Varnedoe, *Jasper Johns: A Retrospective*, New York, The Museum of Modern Art, 1996, p. 193.

9 Among those who attended the opening of 'Feu à volonté' and the dinner that followed at La Coupole were Johns, Rauschenberg, Leo Castelli (director of the Leo Castelli Gallery, New York), Iris Clert (director of the Galerie Iris Clert, Paris), Lawrence Rubin (director of Galerie Lawrence, Paris), Harry Mathews (Saint Phalle's

first husband), Eva Aeppli (Tinguely's first wife), American artist Frank Stella, and the *Nouveaux Réalistes* – an international group of young artists, gallerists and friends.

10 Pierre Restany, 'Modern Nature', in *Breakthroughs: Avant-Garde Artists in Europe and America, 1950–1990*, New York, Rizzoli International, 1991, p. 42.

11 'The Art of Assemblage' then travelled to the Dallas Museum of Contemporary Arts in Dallas, Texas (9 January–11 February 1962) and to the Museum of Modern Art in San Francisco, California (5 March–15 April 1962). It was accompanied by a comprehensive and lavish catalogue – 176 pages, 146 plates (11 colour), including a working bibliography that encompassed the movement in general and each artist.

12 Ed Kienholz in Susan Hapgood, *Neo-Dada: Redefining Art, 1958–62*, New York, The American Federation of Arts and Universe Publishing, 1994, pp. 51, 65 note 135.

13 'Jean Tinguely', Everett Ellin Gallery (4 March 1962); 'Robert Rauschenberg', Dwan Gallery (4–31 March 1962); 'Edward Kienholz Presents a Tableau at the Ferus Gallery', Ferus Gallery (6–24 March 1962).

14 Description compiled from information in Pontus Hulten, *Niki de Saint Phalle*, Bonn, Kunst-und Ausstellungshalle der Bundesrepublik Deutschland, 1992; English edition, Glasgow, McLellan Galleries, 1993, pp. 46–47; and Lois Dickert, 'Shooting at Malibu' (Summer 1962), unpublished manuscript, Niki de Saint Phalle archives, Escondido, California.

15 Virginia Dwan, 'They all came', in *Virginia Dwan et les Nouveaux Réalistes: Los Angeles: Les Années 60*, Paris, Galerie Montaigne, 1990, n.p.

16 Kenneth Koch in correspondence with Nancy Spector, in 'Rauschenberg and Performance, 1963–67: A "Poetry of Infinite Possibilities"', in *Robert Rauschenberg: A Retrospective*, New York, Guggenheim Museum, 1997, p. 244, note 77.

17 4 May 1962: *The Construction of Boston* by Kenneth Koch, directed by Merce Cunningham at the Maidman Playhouse, 42nd Street, New York. With Robert Rauschenberg, Jean Tinguely, Niki de Saint Phalle, Frank Stella, Henry Geldzahler, Maxine Groffsky, Billy Klüver, Oyvind Fahlström, Viola Farber, Steve Paxton, and the Stewed Prunes (McIntyre Dixon and Richard Libertini). Produced by John Wulp. For more on the event see Dempsey, 'The Friendship of America and France'.

18 In 'Marcel Duchamp: Anti-Artist' by Harriet and Sidney Janis, they describe how when making the large glass, Duchamp made nine marks on the glass with matches that had been dipped in paint and fired from a toy cannon. Originally published in the special Duchamp issue of *View*, 5/1, 21 March 1945, reprinted in Robert Motherwell (ed.), *The Dada Painters and Poets: An Anthology* (1951), Cambridge, MA, Belknap Press of Harvard University Press, 2nd edn, 1989, Appendix C, pp. 306–15.

19 The concept of 'art as an institution' is derived from Herbert Marcuse's *The Affirmative Character of Culture*, such that 'art as an institution refers to the productive and distributive apparatus and to the ideas about art that prevail at a given time that determine the reception of works'; cited in Peter Bürger, *The Theory of the Avant-Garde*, Minneapolis, University of Minnesota Press, 1984, p. 12.

20 In January and February of 1962 there were thousands of bombings throughout France, hundreds in Paris. On 8 February an anti-O.A.S. march of some 20,000 protesters was held in Paris. During scuffles with the police who were trying to suppress it, five men and three women were killed. A gigantic funeral march followed a few days later for the victims killed during the protest. In March a ceasefire was signed; in April, ex-General Salan, head of the O.A.S., was arrested in Algiers; his trial took place in May; on 1 July the seven-and-a-half-year war was ended; and on 3 July Algeria was officially independent. See Janet Flanner, *Paris Journal 1944–1965*, New York, Atheneum, 1965, pp. 503–41.

21 The 'hotline' was opened on 30 August 1963.

22 Maurice Berger, 'Forms of Violence: Neo-Dada Performance', in Hapgood, *Neo-Dada*, p. 79.

23 Quoted in Hulten, *Niki de Saint Phalle*, pp. 161–2.

24 See Saint Phalle's 'Letter to Bloum' (her granddaughter) in which she describes the incest she suffered, her nervous breakdown and her salvation through her art. Reprinted in Hapgood, *Neo-Dada*, pp. 141–3.

25 Niki de Saint Phalle, 'Closeup: Avant-Garde Arts', *New York Post*, 5 December 1962, p. 47; quoted in Berger, 'Forms of Violence', p. 79.

Measurements of artworks are given in centimetres, height before width, followed by inches in brackets.

La Fête c. 1953–55
Oil on canvas
127 x 178 cm (50 x 70 ⅟₁₆ in)
© NCAF – Donation Niki de Saint Phalle – Sprengel Mus., Hannover

Family Portrait 1954–55
Oil on canvas
151.3 x 100 cm (59 ⁷⁄₁₆ x 39 ⅜ in)
© NCAF – Donation Niki de Saint Phalle – Sprengel Mus., Hannover

Entre la ville et la fleur (Femme entre la ville et la fleur) c. 1956–58
Oil and various objects on canvas
164 x 116 cm (64 ⁹⁄₁₆ x 45 ¹¹⁄₁₆ in)
© NCAF – Donation Niki de Saint Phalle – Sprengel Mus., Hannover

Pink Nude with Dragon c. 1956–58
Oil and various objects on plywood
143.5 x 200 cm (56 ½ x 78 ¾ in)
© NCAF – Donation Niki de Saint Phalle – Sprengel Mus., Hannover

Scorpion and Stag c. 1956–58
Oil and various objects on plywood
140 x 200 cm (55 ⅛ x 78 ¾ in)
Artist donation, Mamac col., Nice

Broken Plates c. 1958
Plaster and various objects on wood
55 x 65 cm (21 ⅝ x 25 ⁹⁄₁₆ in)
© NCAF – Donation Niki de Saint Phalle – Sprengel Mus., Hannover

Auto-portrait c. 1958–59
Oil and various objects on wood
141 x 141 cm (55 ½ x 55 ½ in)
Col. NCAF. In deposit at Sprengel Museum, Hannover

Assemblage Painting 1959
Paint and metal objects on plywood
130.5 x 195 x 14 cm
(51 ⅜ x 76 ¾ x 5 ½ in)
Artist donation, Mamac col., Nice

Night Experiment c. 1959
Paint, plaster and various objects on plywood
130 x 196 cm (51 ³⁄₁₆ x 77 ³⁄₁₀ in)
© NCAF – Donation Niki de Saint Phalle – Sprengel Mus., Hannover

Sans titre c. 1959–60
Paint and various objects on plywood
62 x 40 cm (24 ⁷⁄₁₆ x 15 ¾ in)
Artist donation, Mamac col., Nice

Sans titre c. 1959–60
Paint and various objects on plywood
60 x 48 cm (23 ⅝ x 18 ⅞ in)
Artist donation, Mamac col., Nice

Le Hachoir 1960
Paint, plaster and objects on plywood
65 x 50 cm (25 ⁹⁄₁₆ x 19 ¹¹⁄₁₆ in)
© NCAF – Donation Niki de Saint Phalle – Sprengel Mus., Hannover

Paysage de la mort (Collage de la mort) 1960
Paint, plaster and various objects on plywood
66 x 50 cm (26 x 19 ¹¹⁄₁₆ in)
© NCAF – Donation Niki de Saint Phalle – Sprengel Mus., Hannover

Ace of Spades c. 1960–61
Plaster and various objects on plywood mounted on wood
27.5 x 18.5 cm (10 ¹³⁄₁₆ x 7 ⁵⁄₁₆ in)
Artist donation, Mamac col., Nice

Fusée et Gant de Caoutchouc c. 1960–61
Paint, plaster, wood and various objects on plywood
54 x 65 cm (21 ¼ x 25 ⁹⁄₁₆ in)
© NCAF – Donation Niki de Saint Phalle – Sprengel Mus., Hannover

Gant de Travail c. 1960–61
Paint, plaster and various objects on wood
34 x 32 x 6 cm
(13 ⅜ x 12 ⅝ x 2 ⅜ in)
Artist donation, Mamac col., Nice

Queen of Hearts c. 1960–61
Wood and various objects on wood
56 x 40.5 cm (22 ¹⁄₁₆ x 15 ¹⁵⁄₁₆ in)
© NCAF – Donation Niki de Saint Phalle – Sprengel Mus., Hannover

Revolution c. 1960–61
Paint, plaster and various objects on plywood
62 x 50 cm (24 ⁷⁄₁₆ x 19 ¹¹⁄₁₆ in)
© NCAF – Donation Niki de Saint Phalle – Sprengel Mus., Hannover

Rubber Glove and Three of Spades c. 1960–61
Plaster and various objects on plywood mounted on wood
78 x 57 cm (30 ¹¹⁄₁₆ x 22 ⁷⁄₁₆ in)
© NCAF – Donation Niki de Saint Phalle – Sprengel Mus., Hannover

Toy Yellow Car c. 1960–61
Paint, plaster, wood and various objects on plywood
54.5 x 65 cm (21 ⁷⁄₁₆ x 25 ⁹⁄₁₆ in)
© NCAF – Donation Niki de Saint Phalle – Sprengel Mus., Hannover

Two Cowboys c. 1960–61
Paint, plaster and various objects on plywood mounted on wood
32.5 x 34.5 cm (12 ¹³⁄₁₆ x 13 ⁹⁄₁₆ in)
© NCAF – Donation Niki de Saint Phalle – Sprengel Mus., Hannover

Van Harte Betterschap (Valentine) c. 1960–61
Plaster and various objects on plywood mounted on wood
57 x 84 x 21 cm
(22 ⁷⁄₁₆ x 33 ¹⁄₁₆ x 8 ¼ in)
Artist donation, Mamac col., Nice

Violon c. 1960–61
Paint, plaster and various objects on wood
65 x 50.2 x 17.8 cm
(25 ½ x 19 ⅝ x 7 in)
Artist donation, Mamac col., Nice

Brooch 1961
Paint, plaster and small found objects on masonite
5.7 x 8 x 1.5 cm (2 ¼ x 3 ⅛ x ⁹⁄₁₆ in)
Col. NCAF, Santee, California

Chess Pawn 1961
Paint, plaster and small found objects on masonite
57.6 x 5.7 x 1.9 cm (3 x 2 ¼ x ¾ in)
Col. NCAF, Santee, California

Fleur 1961
Paint, plaster and small found objects on masonite
8.2 x 6.2 x 1.2 cm (3 ¼ x 2 ⁷⁄₁₆ x ½ in)
Col. NCAF, Santee, California

Grand Tir, séance Galerie J. 1961
Paint, plaster and various objects on plywood
143 x 77 cm (56 ⁵⁄₁₆ x 30 ⁵⁄₁₆ in)
Collection NCAF. In deposit at Mamac, Nice

*Hommage to Bob Rauschenberg
(Shot by Rauschenberg)* 1961
Paint, plaster and various objects
on wood shutter
188 x 55 cm (74 x 21⅝ in)
©NCAF–Donation Niki de Saint
Phalle – Sprengel Mus., Hannover

*Old Master – séance Galerie J,
30 June – 12 July 1961* 1961
Paint, plaster and wire mesh on
panel in an antique frame
73 x 62 cm (28¾ x 24⁷⁄₁₆ in)
Artist donation, Mamac col., Nice

Old Master (non tiré) c. 1961
Plaster on panel in an antique
golden wooden frame
35.5 x 32 cm (14 x 12⅝ in)
Artist donation, Mamac col., Nice

Petit Chapeau 1961
Paint, plaster and small found
objects on masonite
7.8 x 6.3 x 1.9 cm
(3¹⁄₁₆ x 2½ x ¾ in)
Col. NCAF, Santee, California

Petit Sombrero 1961
Paint, plaster and small found
objects on masonite
7.8 x 6.3 x 1.2 cm
(3¹⁄₁₆ x 2½ x ½ in)
Col. NCAF, Santee, California

Red I 1961
Paint, plaster and small found
objects on masonite
7.6 x 6.3 x 1.2 cm
(3 x 2½ x ½ in)
Col. NCAF, Santee, California

Red Ribbon 1961
Paint, plaster and small found
objects on masonite
9.5 x 7.6 x 0.6 cm (3¾ x 3 x ¼ in)
Col. NCAF, Santee, California

Rusty Nail I 1961
Paint, plaster and small found
objects on masonite
7.6 x 12 x 0.6 cm (3 x 4¾ x ¼ in)
Col. NCAF, Santee, California

*Saint Sébastien (Portrait of
my Lover)* 1961
Paint, wood and various objects
on wood
72 x 55 cm (28⅜ x 21⅝ in)
©NCAF–Donation Niki de Saint
Phalle – Sprengel Mus., Hannover

Screw Hook 1961
Paint, plaster and small found
objects on masonite
5.7 x 7.6 x 3.1 cm
(2¼ x 3 x 1¼ in)
Col. NCAF, Santee, California

*Shooting Painting American
Embassy 1961, Paris* 1961
Paint, plaster and various objects
on wood
245 x 66 x 22 cm
(96⁷⁄₁₆ x 26 x 8¹¹⁄₁₆ in)
Col. NCAF. In deposit at Mamac,
Nice

Shooting Picture, Tirage 1961
Plaster, paint, string, polythene and
wire on wood
143 x 78 x 8.1 cm
(56⁵⁄₁₆ x 30¹¹⁄₁₆ x 3³⁄₁₆ in)
Tate. Purchased 1984

String I 1961
Paint, plaster and small found
objects on masonite
6.3 x 6.9 x 1.2 cm
(2½ x 2¹¹⁄₁₆ x ½ in)
Col. NCAF, Santee, California

String 4 1961
Paint, plaster and small found
objects on masonite
8.2 x 6.3 cm (3¼ x 2½ in)
Col. NCAF, Santee, California

String 5 1961
Paint, plaster and small found
objects on masonite
7.6 x 5.7 x 0.6 cm (3 x 2¼ x ¼ in)
Col. NCAF, Santee, California

String 6 1961
Paint, plaster and small found
objects on masonite
8.2 x 6.3 cm (3¼ x 2½ in)
Col. NCAF, Santee, California

*Tir à la raquette – séance Galerie
J., 30 June – 12 July 1961* 1961
Gold paint, plaster and various
objects on wood
60 x 35 x 11 cm
(23⅝ x 13¾ x 4⁵⁄₁₆ in)
Artist donation, Mamac col., Nice

Wood Ball 1961
Paint, plaster and small found
objects on masonite
7.6 x 6.3 x 2.5 cm (3 x 2½ x 1 in)
Col. NCAF, Santee, California

Kennedy-Khrushchev 1962
Paint, wire mesh and various
objects on wood
200 x 120 x 20 cm (78¾ x 47¼ in)
©NCAF–Donation Niki de Saint
Phalle – Sprengel Mus., Hannover

La Mort du Patriarche 1962/72
Paint and various objects
on board
251 x 160 cm (98¹³⁄₁₆ x 63 in)
©NCAF–Donation Niki de Saint
Phalle – Sprengel Mus., Hannover

Long Rifle 1962
Metal and wood
112 cm long (47½ in)
©NCAF–Donation Niki de Saint
Phalle – Sprengel Mus., Hannover

Pirodactyl over New York 1962
Paint, plaster, wood and various
objects (in two parts)
250 x 310 x 30 cm
(98⁷⁄₁₆ x 122¹⁄₁₆ x 1¹³⁄₁₆ in)
Col. NCAF. In deposit at Mamac,
Nice

Shooting Suit 1962
Helanca synthetic fabric
145 x 74 x 15 cm
(57⅛ x 29⅛ x 5⅞ in)
©NCAF–Donation Niki de Saint
Phalle – Sprengel Mus., Hannover

Vénus de Milo 1962
Paint and plaster on metal structure
193 x 63.5 x 63.5 cm
(76 x 25 x 25 in)
Col. NCAF. In deposit at Mamac,
Nice

Autel O.A.S 1962–1992
Bronze
252 x 241 x 41 cm
(99³⁄₁₆ x 94⅞ x 16⅛ in)
Artist donation, Mamac col., Nice

Dragon de Berlin 1963
Paint, plaster, wire mesh and
various objects on wood
180 x 110 x 34 cm (70⅞ x 43⁵⁄₁₆ in)
©NCAF–Donation Niki de Saint
Phalle – Sprengel Mus., Hannover

*Heads of State (Study for
King Kong)* 1963
Paint and masks on wood
125 x 250 cm (49³⁄₁₆ x 98⁷⁄₁₆ in)
©NCAF–Donation Niki de Saint
Phalle – Sprengel Mus., Hannover

King Kong 1963
Paint, plaster and various objects
on board
276 x 611 x 48.4 cm
(108 ¹¹⁄₁₆ x 240 ⁹⁄₁₆ x 19 in)
Moderna Museet Collection,
Stockholm, Sweden

Face/Self Portrait 1963–64
Felt tip pen, ink, stamp, pencil and
gouache on paper
78 x 58 cm (30 ¹¹⁄₁₆ x 22 ¹³⁄₁₆ in)
©NCAF – Donation Niki de Saint
Phalle – Sprengel Mus., Hannover

White Gremlin c. 1963–64
Various objects and fabric on
wire mesh
80 x 50 x 50 cm (31 ½ x 19 ¹¹⁄₁₆ in)
Artist donation, Mamac col., Nice

La Mariée à Cheval 1963–67
Various objects and plaster on
wire mesh
235 x 300 x 120 cm (92 ½ x 118 ½ in)
©NCAF – Donation Niki de Saint
Phalle – Sprengel Mus., Hannover

Autel des Femmes 1964
Paint, wire, mesh and various
objects on wood (3 parts)
250 x 305 x 37 cm (98 ⁷⁄₁₆ x 120 ⅛ in)
©NCAF – Donation Niki de Saint
Phalle – Sprengel Mus., Hannover

Clarissa 1964
Felt tip pen, ink, stamp, pencil and
gouache on paper
65 x 51 cm (25 ⁹⁄₁₆ x 20 ⅛ in)
©NCAF – Donation Niki de Saint
Phalle – Sprengel Mus., Hannover

Vénus 1964
Wool, various objects on wire mesh
170 cm (66 ¹⁵⁄₁₆ in)
Artist donation, Mamac col., Nice

*Black Rosy (My Heart Belongs
to Rosy)* 1965
Material, wool, paint and wire mesh
225 x 150 x 85 cm
(88 ⁹⁄₁₆ x 59 ⅛ x 33 ⁷⁄₁₆ in)
Collection NCAF. In deposit at
Mamac, Nice

*The Bride / Miss Haversham's
Dream* 1965
Various objects on wire mesh
190 x 194 x 75 cm (74¹³⁄₁₆ x 76 ⅜ in)
Col. NCAF. In deposit at Sprengel
Museum, Hannover

Crucifixion c. 1965
Various objects on wire mesh
245 x 160 x 50 cm
(96 ⁷⁄₁₆ x 63 x 19 ¹¹⁄₁₆ in)
Pompidou Centre, Paris, France
(Musée National d'Art Moderne/
Centre de Création Industrielle)

Erica 1965
Fabric and wool on wire mesh
110 x 95 x 65 cm
(43 ⁵⁄₁₆ x 37 ⅜ x 25 ⁹⁄₁₆ in)
Artist donation, Mamac col., Nice

Nana Écartelée 1965
Fabric and wool on wire mesh
77 x 131 x 69 cm (30 ⁵⁄₁₆ x 51 ⁹⁄₁₆ in)
©NCAF – Donation Niki de Saint
Phalle – Sprengel Mus., Hannover

*Nana Noire (Maillot de Bain
Vert)* 1965
Paint, wool, fabric on wire mesh
77 x 131 x 128 cm (30 ⁵⁄₁₆ x 51 ⁹⁄₁₆ in)
©NCAF – Donation Niki de Saint
Phalle – Sprengel Mus., Hannover

Nana Noire Upside-down
1965–66
Paint, wool, fabric on wire mesh
150 x 105 x 108 cm
(59 ⅛ x 41 ⁵⁄₁₆ x 42 ½ in)
Artist donation, Mamac col., Nice

Last night I had a dream 1968
Pen, pencil and gouache on paper
50 x 70 cm (19 ¹¹⁄₁₆ x 27 ⁹⁄₁₆ in)
©NCAF – Donation Niki de Saint
Phalle – Sprengel Mus., Hannover

My love we won't... 1968
Gouache, pen and collage on paper
49.3 x 61 cm (19 ⁷⁄₁₆ x 24 in)
©NCAF – Donation Niki de Saint
Phalle – Sprengel Mus., Hannover

My love what are you doing 1968
Pen and gouache on paper
49.3 x 61 cm (19 ⁷⁄₁₆ x 24 in)
©NCAF – Donation Niki de Saint
Phalle – Sprengel Mus., Hannover

Sweet Sexy Clarice 1968
Silk-screen
59 x 74 cm (23 ¼ x 29 ⅛ in)
Artist donation, Mamac col., Nice

Why don't you love me 1968
Silk-screen
40 x 60 cm (15 ¾ x 23 ⅝ in)
Artist donation, Mamac col., Nice

*You are my love for ever and
never* 1968
Silk-screen
40 x 60 cm (15 ¾ x 23 ⅝ in)
Artist donation, Mamac col., Nice

Last Night I Had a Dream
1968–88
Painted polyester
Dimensions variable
Col. NCAF, Santee, California

*Dear Diana, I had a
marvellous time* 1969
Lithograph
56.4 x 75.5 cm
(22 ³⁄₁₆ x 29 ¾ in)
Artist donation, Mamac col., Nice

Our love was a beautiful flower
1969
Silk-screen
50 x 57.4 cm (19 ¹¹⁄₁₆ x 22 ⅝ in)
©NCAF – Donation Niki de Saint
Phalle – Sprengel Mus., Hannover

I like you rather a lot you fool
1970
Silk-screen
50 x 65 cm (19 ¹¹⁄₁₆ x 25 ⁹⁄₁₆ in)
Artist donation, Mamac col., Nice

La Rêve de Diane 1970
Lithograph
60 x 83.5 cm (23 ⅝ x 32 ⅞ in)
Artist donation, Mamac col., Nice

Nana Power 1970
Lithograph
76 x 56 cm (29 ¹⁵⁄₁₆ x 22 ⅛ in)
©NCAF – Donation Niki de Saint
Phalle – Sprengel Mus., Hannover

Nana Power 1970
Silk-screen
76 x 56 cm (29 ¹⁵⁄₁₆ x 22 ⅛ in)
©NCAF – Donation Niki de Saint
Phalle – Sprengel Mus., Hannover

*What do you like about me
most* 1970
Silk-screen
50 x 65.3 cm
(19 ¹¹⁄₁₆ x 25 ¹¹⁄₁₆ in)
Artist donation, Mamac col., Nice

Daddy: Crucifix (film décor)
1972
Various objects on wire mesh
90 x 80 cm (35 ⁷⁄₁₆ x 31 ½ in)
Artist donation, Mamac col., Nice

Daddy 1973
Film transferred to DVD
Colour and black & white, 60 mins.
Directed by Peter Whitehead
Col. NCAF, Santee, California

Dear Laura 1980
Silk-screen
52 x 73 cm (20½ x 28¾ in)
Artist donation, Mamac col., Nice

La Tempérance (Jardin des Tarots) 1985
Painted polyester
72 x 53 x 23 cm (28⅜ x 20⅞ x 9 1⁄16 in)
© NCAF – Donation Niki de Saint Phalle – Sprengel Mus., Hannover

L'arbre de Vie 1987
Silk-screen
48.5 x 63.5 cm (19⅛ x 25 in)
Artist donation, Mamac col., Nice

The Devil, O.J 1988
Painted polyester
260 x 225 x 110 cm
(102⅜ x 88 9⁄16 x 43 5⁄16 in)
© NCAF – Donation Niki de Saint Phalle – Sprengel Mus., Hannover

Le Pendu 1988
Painted polyester and rope
284 x 100 x 10 cm
(111 13⁄16 x 39⅜ x 3 15⁄16 in)
© NCAF – Donation Niki de Saint Phalle – Sprengel Mus., Hannover

Tarot Garden 1991
Lithograph
61 x 80 cm (24 x 31½ in)
Artist donation, Mamac col., Nice

Hommage à Jean 1992
Silk-screen
65 x 50 cm (25 9⁄16 x 19 11⁄16 in)
Artist donation, Mamac col., Nice

Black is different 1994
Silk-screen
80 x 120 cm (29½ x 47¼ in)
Artist donation, Mamac col., Nice

Tempérance 1994
Silk-screen
80 x 120 cm (29½ x 47¼ in)
Artist donation, Mamac col., Nice

Austrich 1995
Lithograph
66 x 49 cm (26 x 19 5⁄16 in)
Artist donation, Mamac col., Nice

Rhino 1995
Lithograph and collage
30.5 x 46 cm (12 x 18⅛ in)
Artist donation, Mamac col., Nice

Monster 1996
Lithograph
23.6 x 24 cm
(108 5⁄16 x 108 7⁄16 in)
© NCAF – Donation Niki de Saint Phalle – Sprengel Mus., Hannover

Noah's Animals 1996
Lithograph
62 x 80 cm (24 x 31½ in)
Artist donation, Mamac col., Nice

The Falling Tower 1997
Lithograph
75.5 x 56.5 cm (29¾ x 22¼ in)
Artist donation, Mamac col., Nice

L'ange Protecteur 1997
Lithograph
75.5 x 56.5 cm (29¾ x 22¼ in)
Artist donation, Mamac col., Nice

L'estrella 1997
Lithograph
55.5 x 40 cm (21⅞ x 15¾ in)
Artist donation, Mamac col., Nice

La Lune 1997
Lithograph
75.5 x 56.5 cm (29¾ x 22¼ in)
Artist donation, Mamac col., Nice

Tempérance 1997
Lithograph
75.5 x 56.5 cm (29¾ x 22¼ in)
Artist donation, Mamac col., Nice

The Devil 1998
Silk-screen
75.2 x 56.2 cm (29 x 22⅛ in)
Artist donation, Mamac col., Nice

The Hierophant Card V 1998
Lithograph
75.5 x 56.5 cm (29¾ x 22¼ in)
Artist donation, Mamac col., Nice

Strength (Card II) 1998
Lithograph
56.5 x 75.5 cm (22¼ x 29¾ in)
Artist donation, Mamac col., Nice

The Sun 1998
Lithograph
75.5 x 56.5 cm (29¾ x 22¼ in)
Artist donation, Mamac col., Nice

The Hanged Man 1999
Lithograph
75.5 x 65.6 cm (29¾ x 25 13⁄16 in)
Artist donation, Mamac col., Nice

La Justice (Carte VIII) 1999
Lithograph
75.5 x 56.5 cm (29¾ x 22¼ in)
Artist donation, Mamac col., Nice

The Lovers 1999
Dry point and wash drawing
48.4 x 40.6 cm (19 1⁄16 x 16 in)
Artist donation, Mamac col., Nice

Nana Santé 1999
Lithograph
61.4 x 49.2 cm (24 3⁄16 x 19⅜ in)
Artist donation, Mamac col., Nice